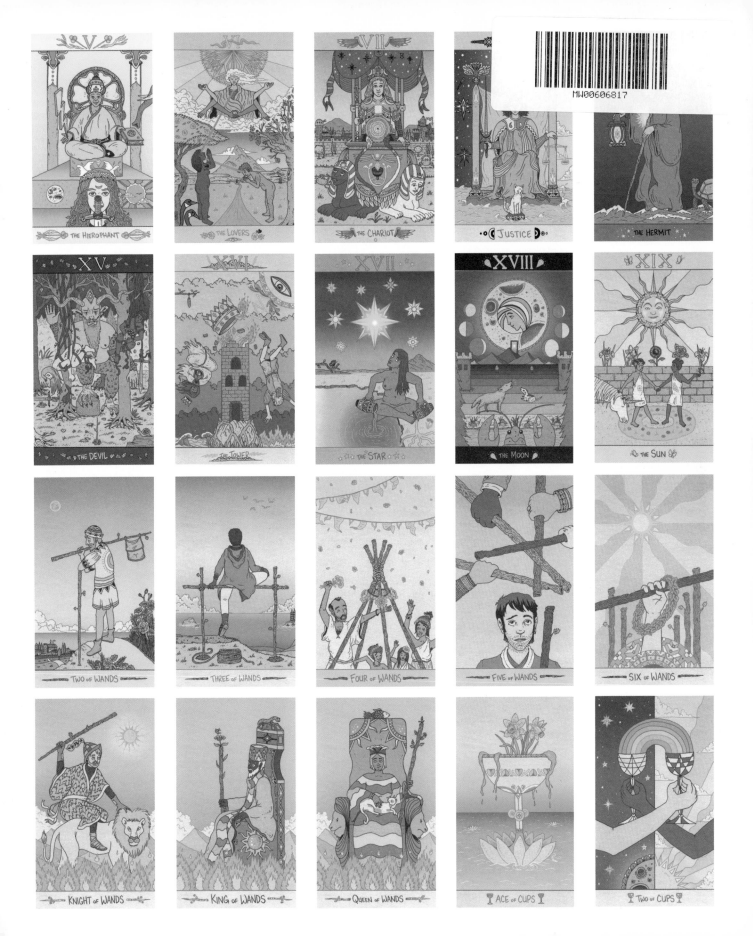

First published in 2022 by Liminal 11

Images copyright © 2022 Kay Medaglia

Editorial Director: Darren Shill
Artistic Director: Kay Medaglia
Editor: Eleanor Tremeer
Graphic Designers: Tori Jones, Jing Lau, Gill Ha,
Fern Cleary and Allie Oldfield
Cover Design: Jing Lau

Printed in China

ISBN 978-1-912634-31-6

10 9 8 7 6 5 4 3 2 1

www.liminal11.com

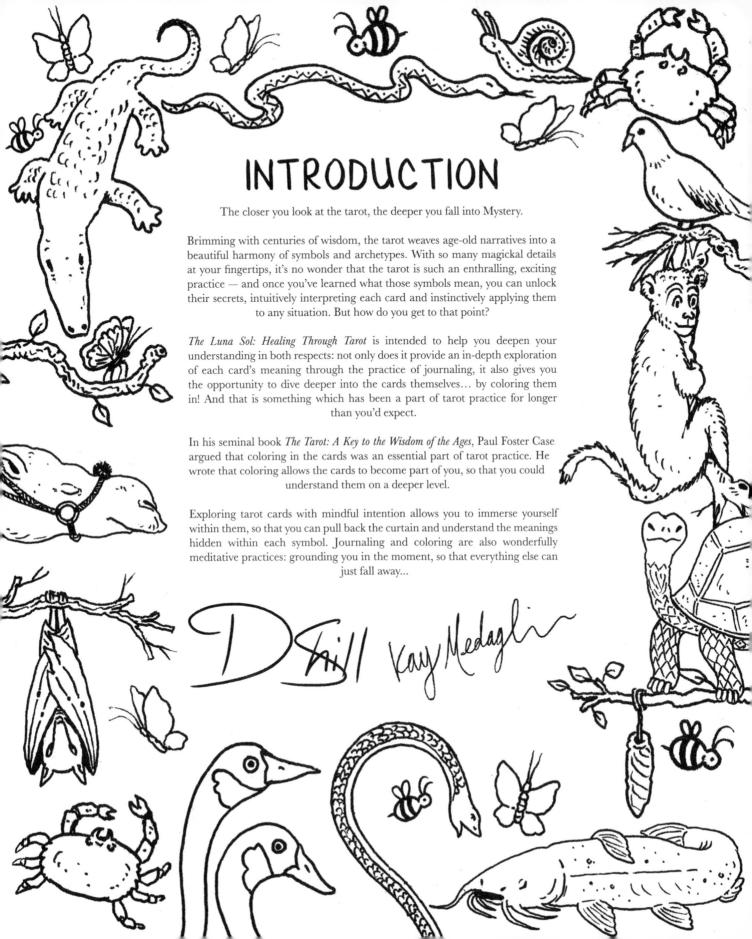

INTRODUCTION

The closer you look at the tarot, the deeper you fall into Mystery.

Brimming with centuries of wisdom, the tarot weaves age-old narratives into a beautiful harmony of symbols and archetypes. With so many magickal details at your fingertips, it's no wonder that the tarot is such an enthralling, exciting practice — and once you've learned what those symbols mean, you can unlock their secrets, intuitively interpreting each card and instinctively applying them to any situation. But how do you get to that point?

The Luna Sol: Healing Through Tarot is intended to help you deepen your understanding in both respects: not only does it provide an in-depth exploration of each card's meaning through the practice of journaling, it also gives you the opportunity to dive deeper into the cards themselves... by coloring them in! And that is something which has been a part of tarot practice for longer than you'd expect.

In his seminal book *The Tarot: A Key to the Wisdom of the Ages*, Paul Foster Case argued that coloring in the cards was an essential part of tarot practice. He wrote that coloring allows the cards to become part of you, so that you could understand them on a deeper level.

Exploring tarot cards with mindful intention allows you to immerse yourself within them, so that you can pull back the curtain and understand the meanings hidden within each symbol. Journaling and coloring are also wonderfully meditative practices: grounding you in the moment, so that everything else can just fall away...

HOW TO USE THIS BOOK

There's a lot going on in this book! To break it down, in this coloring book you will find...

- A line-art version of **each card** to color in.
- A list of **symbols**.
- An exploration of the card, as it relates to **healing** and **spirituality**.
- Two **questions** to help you reflect on what each card means to you.
- A **practical exercise** to immerse you in the card's meaning.
- A beautiful **mandala** for you to color in.

When we set out to create *The Luna Sol Tarot*, we wanted it to be a healing, comforting experience, and we've approached this book in the same way. When we are at our lowest ebb, we often turn to tarot, so we know first-hand how difficult some of the cards can be to pull when you're at your most vulnerable. But we also know that no matter how bleak things look, the sun will always rise again.

Because of this, we made sure to infuse the *Luna Sol* with a sense of compassion and care. The deck is painted in pastel shades, while the meanings are encouraging and empowering. This coloring book is no different: for every card, you'll find a **path of healing**. This is an explanation of how each card applies to a journey of self-healing, recovery, empowerment, and introspection.

You'll also find an exploration of the **spirituality** of each card. This delves into the mythological archetypes and spiritual practices that apply to the card in question — from Norse legends to Taoism.

And finally, to really help you learn from each card, you'll also find two **reflections** — questions that invite you to apply the card's themes to your own life — and an **exercise** that will put what you've learnt into practice. These range from meditations to mind maps to visualisation techniques.

But of course, coloring the card is the most important part of all. And each color has a distinct thematic meaning...

- **Yellow** — light, divinity
- **Brown** — earth, groundedness
- **Green** — nature, life
- **Blue** — emotion, the subconscious
- **Purple** — mystery, turmoil

- **Pink** — love, kindness
- **Red** — passion, authority
- **Gray** — knowledge, aspiration
- **Black** — depth, secrets
- **White** — purity, innocence

Ready? Then assemble your coloring materials, and let's plumb the depths of the *Luna Sol Tarot*...

A NOTE ON GENDER

In this book, we are exploring gender on an archetypal and spiritual basis, which is distinct from gender as a social construct. (As a social construct, we are assigned a gender at birth. We may identify with that gender, or a different gender — or even no gender!)

For some tarot cards, gender is an important part of their meaning. Male/female genders have multiple connotations, like duality, the divine feminine, patriarchal power, etc. In this book, we use 'he/she' pronouns for these cards. However, the figures in some tarot cards are gender-neutral, non-binary, or spiritually androgynous*. For these figures, we use 'they/them' pronouns.

Overall, our use of gender in this book is meant to help you explore the difference between spiritual gender and gender in the real world. The Empress, for example, is the epitome of feminine energy; however, anyone can play her role in reality, even if they identify as male or non-binary. Think of it this way: anyone can be the 'mom friend' in a friendship group! And even archetypal gender is fluid — we are free to move in and out and around archetypes as they hold meaning for us. They are tools for understanding, and not prisons for our being — like a cosmic suit of armor!

Here's a breakdown of each card's gender attributions and why we chose them...

THE FOOL is **gender-neutral** — the spirit of new adventure is neutral, as is the idea of nothingness that the Fool embodies.

THE MAGICIAN is **male** — yet he is also a trickster who wears many faces…

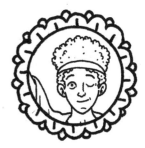

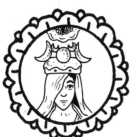

THE HIGH PRIESTESS is **female** — she is the natural counterpart of the Magician, the other side of the coin. Their genders express duality — but is the High Priestess just another face that the Magician wears?

* Androgyny is a foundational part of many spiritual schools of thought, from alchemy to Kabbalah to Hinduism. If male and female represent the duality, the separateness of humanity, and therefore all of existence, then androgyny is the unity that precedes this mortal separateness — a primeval unity that we are on a journey to return to. Throughout history and in multiple cultures, intersex individuals were elevated as priests and spiritual leaders, because they embodied this notion of androgyny-as-unity.

This is a fascinating part of gender history, and one which has largely been ignored and erased in Western religion, history, and literature. The tarot, however, utilizes the idea of spiritual androgyny in multiple cards — which gives us yet another insight into what a kaleidoscope gender really is!

THE EMPRESS is **female** — she is Mother Nature incarnate.

THE EMPEROR is **male** — he is patriarchy, the masculine drive to push forward.

THE HIEROPHANT is **neutral** — there are many teachers who come in many forms. Yet, you could see the Hierophant as **male**, an expression of patriarchy in educational institutions. To counter this, the **female** Isis appears on this card, symbolic of feminine resistance to sexist exclusionism and gatekeeping.

THE LOVERS are **male and female** — this is an expression of duality, not of biological form. The angel on this card is a **third gender**, one we cannot quite understand…

THE CHARIOT'S rider is **neutral** — the role of the champion is not ascribed to any particular gender.

JUSTICE is **female** — a personification that harkens back to the goddess Iustitia of Ancient Rome, and other justice goddesses that came before her.

THE HERMIT is **neutral** — because although traditionally the Hermit is an old man, anyone can walk this path; gender is not a fundamental aspect of this archetype.

STRENGTH'S human aspect is **female** — she is beauty to the lion's beast, femininity as a nurturing, subversive force.

THE HANGED ONE is **neutral** — this card's power lies in subverting norms and finding a middle way. This is universally applicable, hence gender neutrality, but as gender neutrality is itself subversive and a middle way, it fits very well with the card's theme.

DEATH is **neutral** — it's impossible to gender part of the life cycle.

TEMPERANCE is **non-binary** — they are an angel, beyond our human perception of gender.

THE DEVIL is **androgynous** — traditional depictions reveal them to be intersex, which relates to alchemical notions of androgyny (see footnote). The Devil's prisoners are **male and female**, expressing duality and harkening back to the Lovers.

THE TOWER'S falling figures are **male and female** — again, to represent duality.

THE STAR is **non-binary** — this card's meaning is creative potential, so in terms of gender, the figure transcends binary notions to create themself however they want to be.

THE SUN'S two children are **neutral** — they have not yet grown into their genders, and have all the time in the world to discover what gender means to them.

JUDGEMENT'S otherworldly figure is **non-binary** — like the angels, they soar beyond our mortal comprehension.

THE WORLD'S dancer is **androgynous** — spiritual androgyny is thought of as being the ultimate form of humanity: after millennia divided, humanity's apotheosis occurs when we can finally come together as one being. As that is the theme of the World card, so the figure has always been thought of as androgynous.

When you start to see gender as archetypal and spiritual, you'll notice that there are actually plenty of expressions of gender beyond our perception of male and female. Because of the constraints of language, however, we have only three pronouns — he, she, and they — but that does not mean that there are only three genders. 'Non-binary', 'gender-neutral', and 'androgynous' each have distinct connotations, and there are other gender concepts beyond even these examples. By ascribing genders beyond the traditional binary to the tarot, we are using gender as a means to explore the themes of each card, while expanding the idea of gender itself.

But that's not to say that the male/female genders are one-dimensional. Far from it! The concepts of female and male are vast and contain multiple connotations, expressions, identities, and social roles spread across the entirety of human culture and existence. Just like the dualities of the tarot, each binary gender is a universe unto itself, and there are wonders to be found in the space in between.

Simply put, it's a rabbit hole! And the more you dive in, the more you'll come to realize that our conventions of gender are far narrower than what actually exists in the material — and spiritual — world.

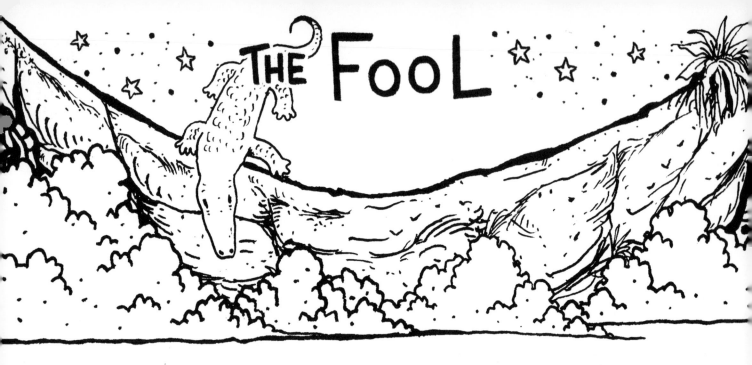

THE FOOL

PATH OF HEALING

The Fool is the first step: to adventure, to recovery, to a new beginning… Everything has to start somewhere. When the Fool appears in a reading, it's time to take the plunge. The whole universe is open to you, and you're full of potential. Notice how the Fool steps out into the abyss — they are walking off a cliff, but the void before them is full of stars. Even free-fall can lead to sparkling wonder. So have faith in yourself… and leap!

SPIRITUALITY

Rather than starting at 1, the Major Arcana starts at 0 — a perfect, empty circle. It is this emptiness that many different philosophies and spiritualities seek to cultivate. In Existentialism, nothingness is pure consciousness; Heidegger said: "Human existence cannot have a relationship with being unless it remains in the midst of nothingness." And we find this concept in more than one philosophy. Meditation invites us to empty our minds of clutter. Taoism teaches that the path to authenticity lies in nothingness — "tao is an empty vessel," taught Lao Tzu. The Fool is nothing… *yet*. But from nothing, everything can be built.

ANIMALS

The Fool is not alone on their journey: beside them is the dog, humanity's best friend in a wilderness of untamed beasts. It leaps with pure *joie de vivre*, the joy of life that the Fool, too, embodies. A domesticated creature, the dog is proof of what wonderful things can come when we work together with nature. A crocodile, emblematic of primitive instincts, peers into the void just beyond the cliff. It represents the reptilian brain — the origin point of our evolution, all impulse and survival instinct. It cannot go further, but the Fool can.

IN A NUTSHELL…

Even the title 'The Fool' explains what this card is all about: before we know anything, we know nothing, and this ignorance is bliss. Fools rush in, but it's crucial that they do — for if we knew what life had in store for us, would we take the plunge? As we become world-weary with age, it can be difficult to recapture the beautiful foolishness of youth. Yet, that seed of potential is within us still; empty your mind, and you may find it again…

SYMBOL SECRETS

DHARMACHAKRA WHEEL

The wheel on the Fool's chest is a Dhamachakra. One of the most ancient symbols, it first appeared in the Indus Valley and dates all the way back to 2500 BCE. The eight spokes represent the eightfold path of Buddhism, and the path to Nirvana. This is also the path of the Major Arcana…

THE SUN

This sun has 11 rays — six for the Higher Self, and five for Humanity. This is also a subtle nod to Liminal 11, the company that was launched to publish this very deck.

SYMBOLS

○ ○ ○ ○ ○ ○ ○ ○

MOON
SUN
MOUNTAINS
BAG
ROSE
LAUREL WREATH
SUN & MOON
DHARMACHAKRA WHEEL
FLOWER
DOG
CROCODILE
LEDGE
STARRY VOID

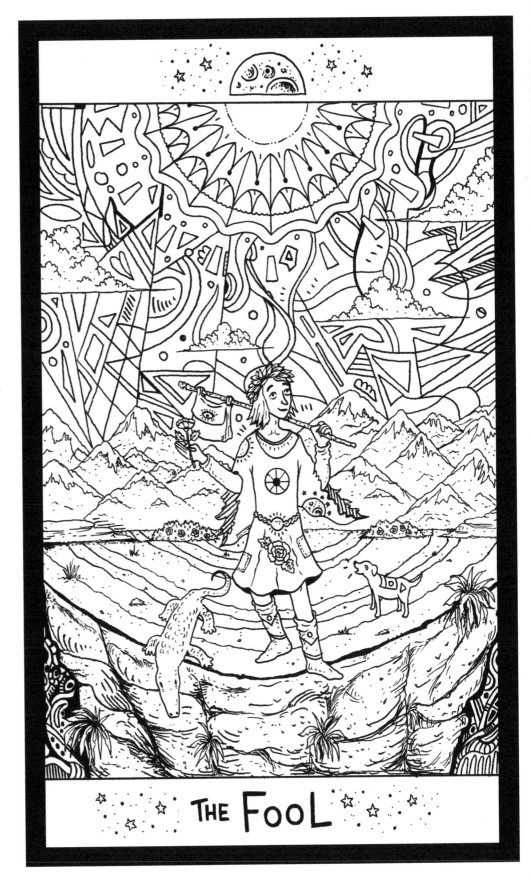

THE FOOL

REFLECTIONS

Is there an area of your life that you'd like a fresh start on?
How do you think you could achieve this new beginning?

..

..

..

..

Was there a time in your life when you felt guided by instinct?
What did that moment teach you about yourself?

..

..

..

..

PRACTICE

Every Tai Chi form begins with the Wu Chi, a simple standing meditation. This is intended not just to ground you but to help you connect with the emptiness at the core of everything. There is silence between sounds, space between objects, a void between thoughts. This meditation will help you find this nothingness; this is the seed from which everything springs.

Stand with your feet together, parallel with your hips. Picture a delicate thread that gently pulls you upright, through your legs to your hips, your spine to your neck, and up through the top of your head to the heavens. Let your arms relax by your sides; your knees, chest, and shoulders should soften as this invisible thread pulls you upwards while your feet connect with the ground. Breathe into this posture and feel that emptiness all around you.

Record anything you find notable about the experience here:

..

..

..

..

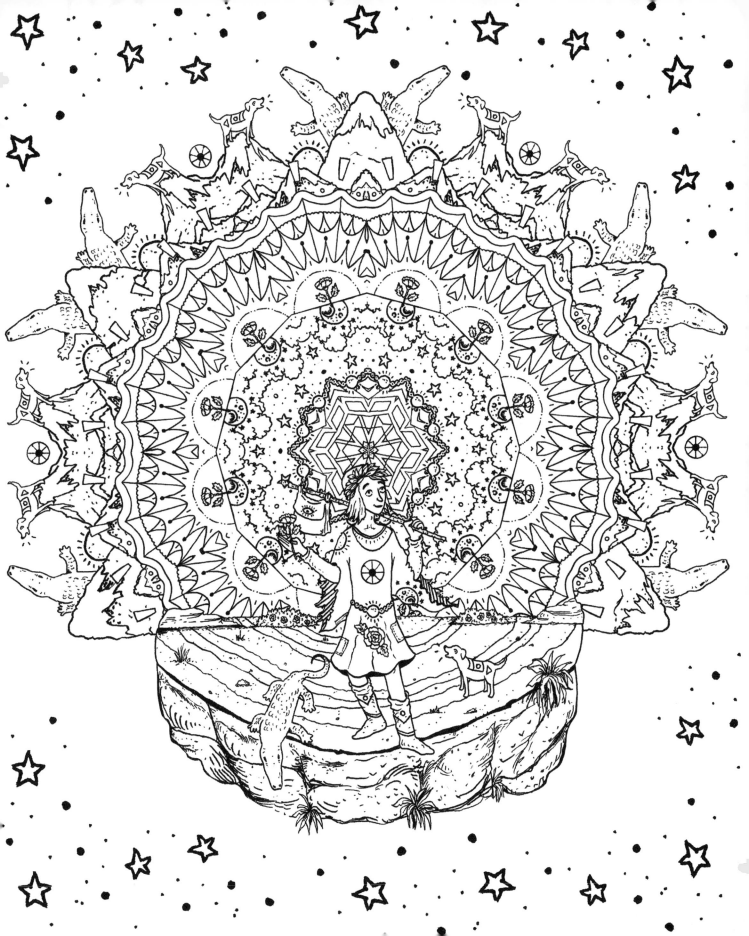

THE MAGICIAN

I

PATH OF HEALING

Now that the first step has been taken, it's time for action. You may feel like it's too soon, but the grand architect of your life is you alone. In order to live, you must create your own path — and there's no better time than the present. So, nurture those seedling ideas! Even if they grow into something you never expected, still, they will become a garden — and it will all be yours.

SPIRITUALITY

The Magician is the trickster creator, plumbing the depths of arcane lore to weave his magickal designs into being. Tricksters are culture heroes, testing boundaries and challenging humanity to move beyond our limitations. The Raven of First Nations' myth, the Greek god Prometheus, Maui of Polynesia — these thieves steal fire from the gods and drag mountains up from the sea so that humans can build better lives. The Magician, however, also deals in illusion — and so do his archetypal blueprints. Hermes, Anansi, Loki, Ophiuchus: all are gods of knowledge, but also of trickery. You can seek to create the Magician's wonders but be wary: no creation comes without a cost.

ANIMALS

Odin's ravens perch by the Magician — the Poetic Edda says that "Hugin and Munin; Fly every day; Over all the world" to bring Odin the wisdom he uses in his sorcery. Hugin and Munin can be translated as 'thought' and 'memory', so they are related to the Magician's role as the mind-ego. Hugin (thought) is on the left of the Magician, looking forward, while Munin (memory) looks backward. Ravens themselves are intelligent, social creatures, known for theft. There's a reason they are associated with trickery in many cultures: they're nature's tricksters!

IN A NUTSHELL...

The Magician's true magic is creation: plucking an idea from the liminal mind-space and transforming it into a reality. Even if your work is not magickal, there is magic in manifestation alone. The Magician urges you to tap into your source of inspiration, transcend the boundary between what is and what could be, and build your dreams in the real world.

SYMBOL SECRETS

WINGS

Mercury, the magician god of Roman myth, flies on winged heels. Through travel, the Magician learns the secrets of many worlds so that he can make new wonders. Here, too, is the eight-pointed sign of Innana, the powerful Mesopotamian goddess who ventured to the Underworld... and back.

INVISIBLE STRINGS

The tools of the Minor Arcana seem to float, levitated by the Magician's magic... but look closer! Are those strings? Hakuin, an 18th century Zen monk, said: "This floating world is but a phantasm. It is a momentary smoke." The winking Magician knows that reality is just a matter of perspective.

SYMBOLS

WINGS
STAR
INVISIBLE STRINGS
DISK
SWORD
CUP
WAND
INFINITY SYMBOL
RAVENS
PILLARS
WAND
SNAKE BELT
ROSES
COINS
BOOKS

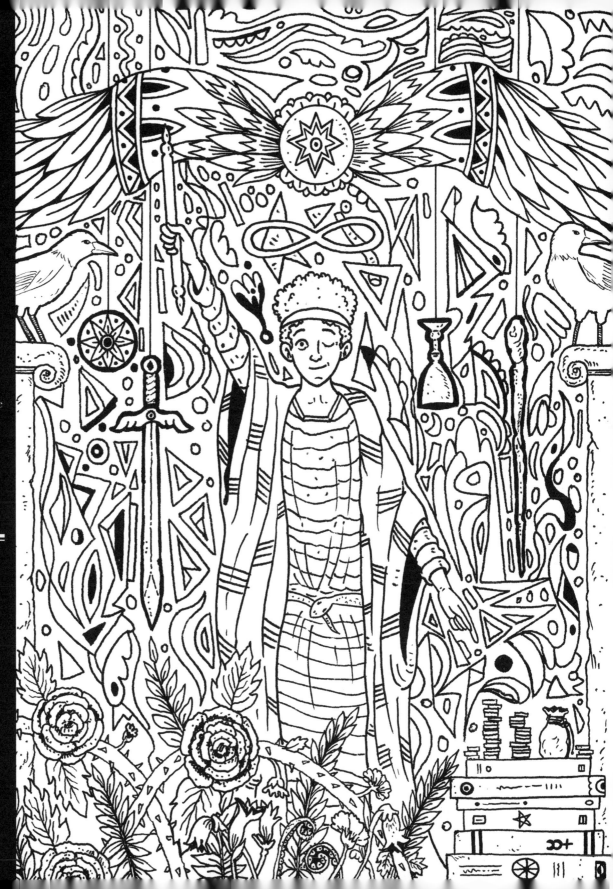

REFLECTIONS

What's a topic you've always been interested in but never had the chance to study seriously?

...

...

...

...

What's holding you back from creating what you want to create? How can you transcend this boundary?

...

...

...

...

PRACTICE

Sometimes creation comes from careful thought and planning; sometimes it's a free-flow process. Take this opportunity to work on a project, just for 15 minutes, that you've been thinking about but haven't got around to doing yet. If you get inspired in that time, then continue — if you don't, then don't!

You can use this space for planning, or for a free-flow of thoughts about the project — write whatever comes to mind here:

...

...

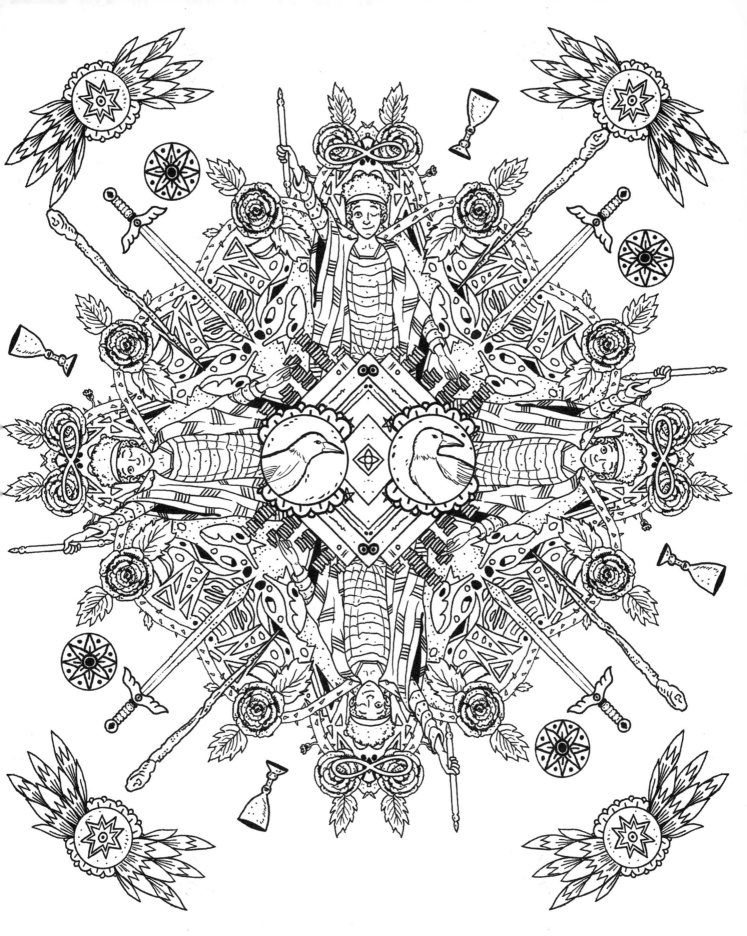

THE HIGH PRIESTESS

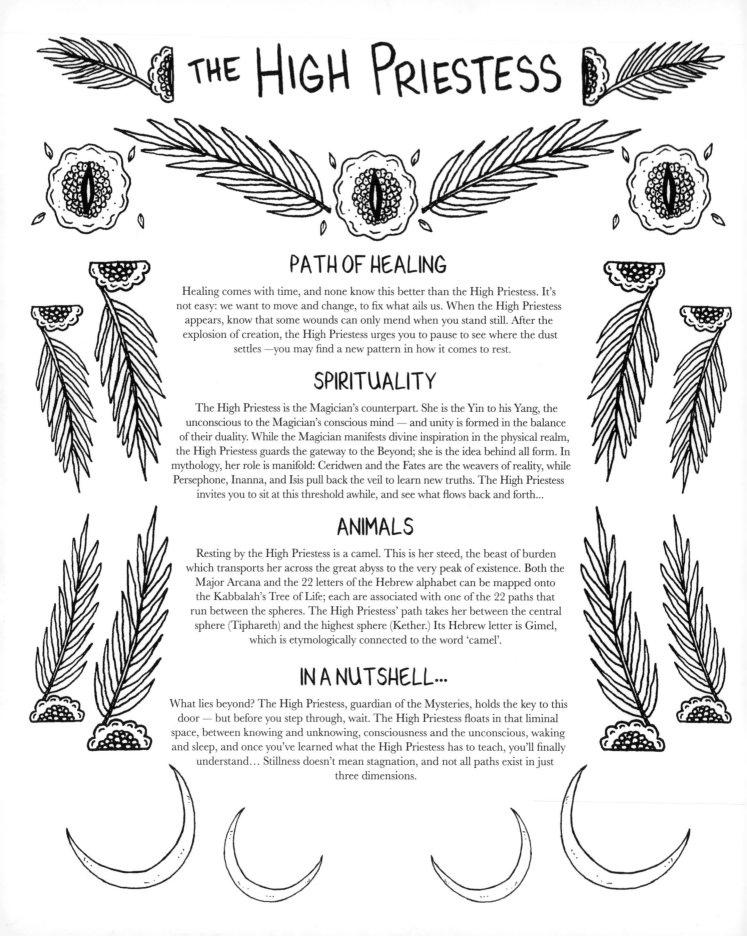

PATH OF HEALING

Healing comes with time, and none know this better than the High Priestess. It's not easy: we want to move and change, to fix what ails us. When the High Priestess appears, know that some wounds can only mend when you stand still. After the explosion of creation, the High Priestess urges you to pause to see where the dust settles —you may find a new pattern in how it comes to rest.

SPIRITUALITY

The High Priestess is the Magician's counterpart. She is the Yin to his Yang, the unconscious to the Magician's conscious mind — and unity is formed in the balance of their duality. While the Magician manifests divine inspiration in the physical realm, the High Priestess guards the gateway to the Beyond; she is the idea behind all form. In mythology, her role is manifold: Ceridwen and the Fates are the weavers of reality, while Persephone, Inanna, and Isis pull back the veil to learn new truths. The High Priestess invites you to sit at this threshold awhile, and see what flows back and forth…

ANIMALS

Resting by the High Priestess is a camel. This is her steed, the beast of burden which transports her across the great abyss to the very peak of existence. Both the Major Arcana and the 22 letters of the Hebrew alphabet can be mapped onto the Kabbalah's Tree of Life; each are associated with one of the 22 paths that run between the spheres. The High Priestess' path takes her between the central sphere (Tiphareth) and the highest sphere (Kether.) Its Hebrew letter is Gimel, which is etymologically connected to the word 'camel'.

IN A NUTSHELL…

What lies beyond? The High Priestess, guardian of the Mysteries, holds the key to this door — but before you step through, wait. The High Priestess floats in that liminal space, between knowing and unknowing, consciousness and the unconscious, waking and sleep, and once you've learned what the High Priestess has to teach, you'll finally understand… Stillness doesn't mean stagnation, and not all paths exist in just three dimensions.

SYMBOL SECRETS

PILLARS

These pillars represent life's dualities: fact and fiction, day and night, wrong and right. This is further conveyed by the symbols that bedeck the pillars: the sun and moon appear again, along with the alchemical signs for fire and water.

VEIL

The High Priestess' veil is decorated with pomegranates, the fruit that Persephone ate in the Underworld. Did the pomegranate trap her, or free her? This fruit is symbolic of the High Priestess' message: only by daring to look beyond can we transcend this mortal coil.

SYMBOLS

VEIL
POMEGRANATES
PILLARS
SUN
MOON
FIRE (ALCHEMICAL SYMBOL)
WATER (ALCHEMICAL SYMBOL)
CROWN
CROSS
BOOK
SEAT
DRESS

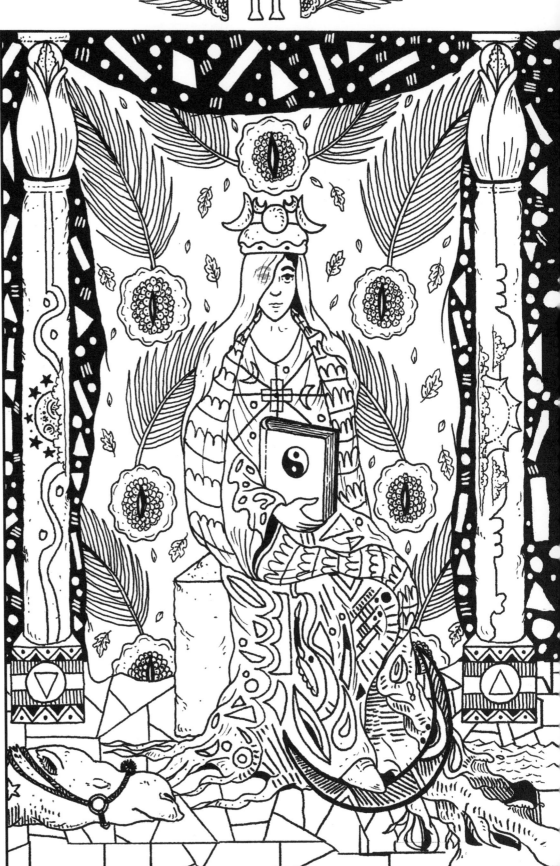

REFLECTIONS

Do you take a more active or passive approach to life? Why?

..

..

..

Revisit a personal threshold in your life. What were you thinking and feeling at the moment before you moved forward? On reflection, would you have taken a different path?

..

..

..

PRACTICE

On a moonlit night, take a moment to contemplate the mysteries of your life. Cast whatever ritual space you find sacred, invoke a threshold deity, and do this three-card tarot spread.

| 1 Conscious: what's weighing on your waking mind | 3 Liminal wisdom from the In-between | 2 Unconscious: what's affecting you subconsciously |

Record the cards and your interpretations here:

..

..

THE EMPRESS

PATH OF HEALING

It can be tempting to tough out the pain. We don't want to be a burden to others, or perhaps we just don't want to be emotionally vulnerable and open to hurt. But humans are loving creatures, and the Empress is nurture incarnate; when she appears, know that there are people out there who love you and want to help. Seek out those who will support you — you don't have to do this alone.

SPIRITUALITY

Mother goddesses are among the most powerful. They embody what it means to nurture, love, and create, and they are not to be underestimated. Demeter, Kali, Eve, Venus, even mythic figures like Medea, or the legendary mortal Cleopatra… These iconic mother-empresses changed and remade the world. Mother Nature, after all, may give us life — but she also gives life to the hurricanes and earthquakes that could strike us down at any moment. Reverence should come with respect, and that is what is owed to the Empress.

ANIMALS

The Empress pets a bull. A furious beast when threatened, the bull is nonetheless crucial to agriculture, helping us till and plow the fields. In this way, they are also representative of harvestime — the gathering of crops and the abundance that comes in the twilight of the year, sustaining us until spring. A humble bee buzzes in the Empress' sceptre, a paragon of community and of teamwork which the Empress also espouses. There are seven bees scattered throughout this deck — can you find them all?

IN A NUTSHELL...

The Empress is the source of all being: she is Tao, the origin and the wellspring, life creating itself. Lao Tzu said that we can all be "nourished by the great mother" if we only reconnect with that universal womb of reality. The Empress is a reminder that through this source we are all connected, and only together can we thrive. Defy individualism and reach out — the best way to honor the Empress is to honor each other.

SYMBOL SECRETS

○ ○ ○ ○ ○ ○ ○ ○

MOTHER

The Empress is the eternal mother goddess. All life begins with her, which is why pregnancy is revered in many cultures as being sacred. Bringing new life into the world is magical — a miracle that happens every day — and those who give birth are vessels of transformation.

STREAM

The stream that flows through the Empress' lush meadow is, in fact, the transformed dress of the High Priestess, the literal fountainhead of the divine unconscious. Follow the water's course through the Major Arcana… where does it all lead?

SYMBOLS

○ ○ ○ ○ ○ ○ ○ ○

TREES
12 STARS
LAUREL CROWN
SCEPTRE
BEE
PREGNANCY
RIVER
MOON CUSHION
VENUS CUSHION
CORN

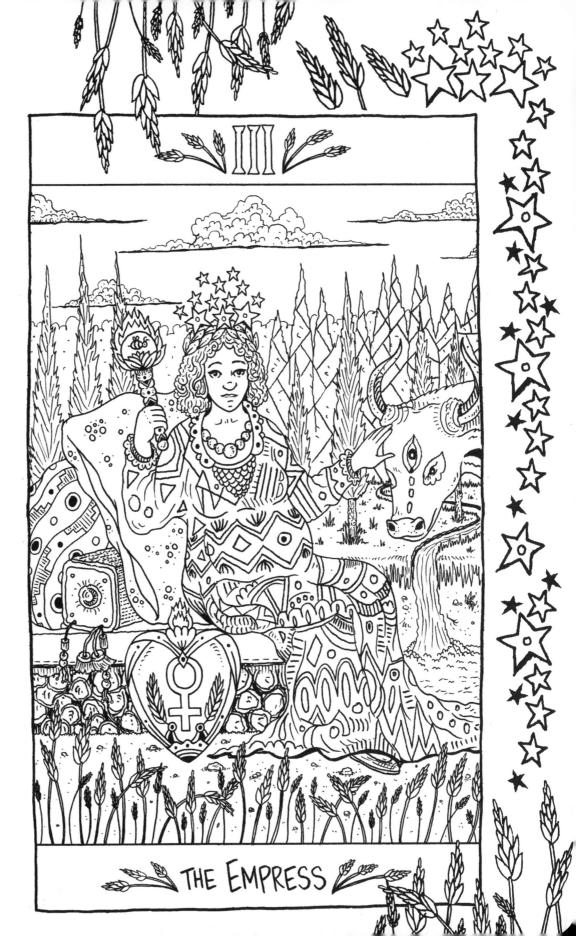

THE EMPRESS

REFLECTIONS

Who in your life represents the Empress? What has the path of your relationship been, and where are you now?

..

..

..

Sometimes you need to be the Empress for someone else. Take this time to reach out to a friend who is going through a hard time. When they want input from you, step back from ego. True support means giving only what is asked for, be it advice, or just a shoulder to cry on. How did this make you feel?

..

..

PRACTICE

Use this space to draw a mind-map of your personal network. Start by placing the names of your closest connections closest to the center, then write the names of your other connections, from the ones you know best through to acquaintances, working outwards as you go.

How are all these people connected to you? How are they connected to each other? You can depict these bonds using colored lines. Choose different colors for different bonds (e.g.: gold for family, green for friendship, red for romance, etc) — but remember, our bonds aren't always so basically categorized. Do you have a particularly intellectual connection with someone? What about a fruitful working relationship?

This exercise should help you understand what people mean to you...

YOU

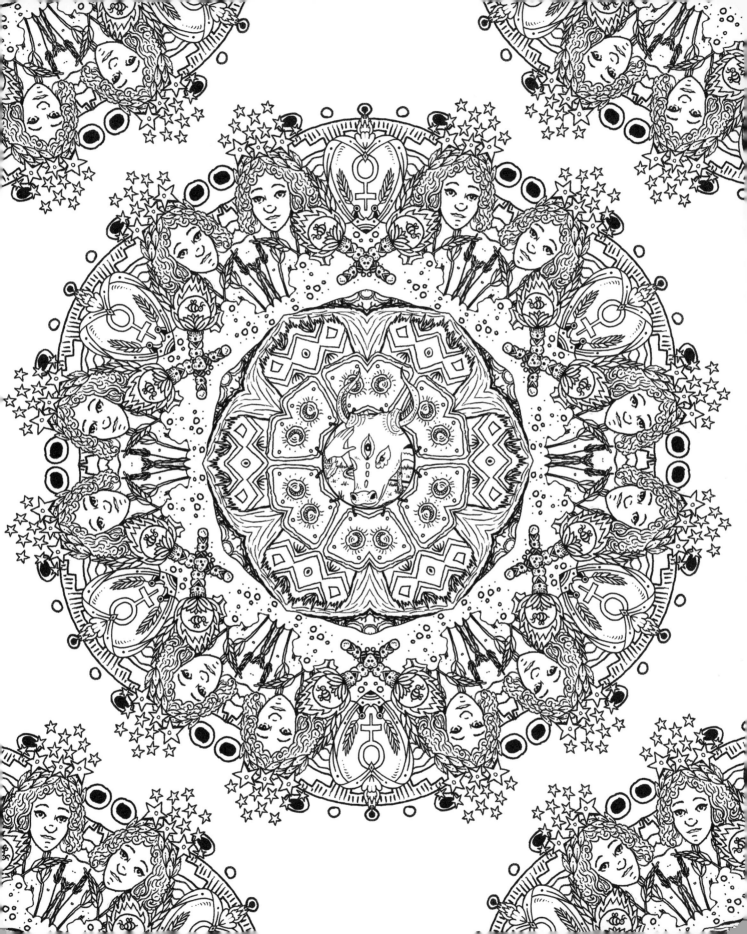

THE EMPEROR

PATH OF HEALING

You've rested, you've received support; now it's time to build. The Emperor is the seat of power in the Major Arcana. When he appears, you can tap into that strength and stability. Take courage, but above all, plan and be pragmatic: what's the most logical solution to your current situation?

SPIRITUALITY

Just as the Empress is the Mother Goddess, so the Emperor is the Father. The ultimate patriarch, he stands for structure and order. He is the architect of our modern age; note the compass in his hand. The Emperor is ruled by Aries, the astrological ram, all fiery spirit and stubborn will. With his legs positioned in such a way, he invokes the alchemical symbol for sulphur — and the '4' pose represents the four corners of the Earth that the Emperor has designs on. He sits at the edge of the wilderness, always pushing forward. But is this progress or invasion?

ANIMALS

A lamb is the Emperor's companion. Long a symbol of innocence, youth, and purity, the lamb represents the vulnerable people that the Emperor protects, for he is also a guardian. Those who live in the Emperor's domain can sleep peacefully at night, safeguarded from the world's dangers. This is the blessing that stability brings, and it's why we rely on the structure of society.

IN A NUTSHELL...

Reality is chaos. We need order as a means to move through it — without order, the world would be incomprehensible, and so we organize everything we encounter into categories that we can understand. This is an animal; that is a plant. This is poison; that is nectar. The Emperor pioneers this ordering of reality — and yet, all rules must be revisited from time to time, lest they restrain us.

SYMBOLS

SUN
MOUNTAINS
DESERT
RIVER
DIAMOND
HORNS
SCEPTRE
ORB

BEE
COMPASS
MARS SYMBOL
CORN
SEAT
SHIELD
LEG POSE

SYMBOL SECRETS

◦ ◦ ◦ ◦ ◦ ◦ ◦

SCEPTRE

The Emperor's sceptre is reminiscent of the Egyptian ankh — a symbol of power, the pharaohs carried the ankh into death. Yet, this sceptre is also related to the Venus symbol, which decorates the Empress' cushion. A good leader can use all the tools at their disposal, and will not be confined to one box or another...

COMPASS

The Emperor's compass is a reference to the painting *Ancient of Days* by William Blake, which depicts Blake's mythic figure Urizen: a patriarchal architect who brings order, exercising control over imagination and creation to craft wonderful, terrible things...

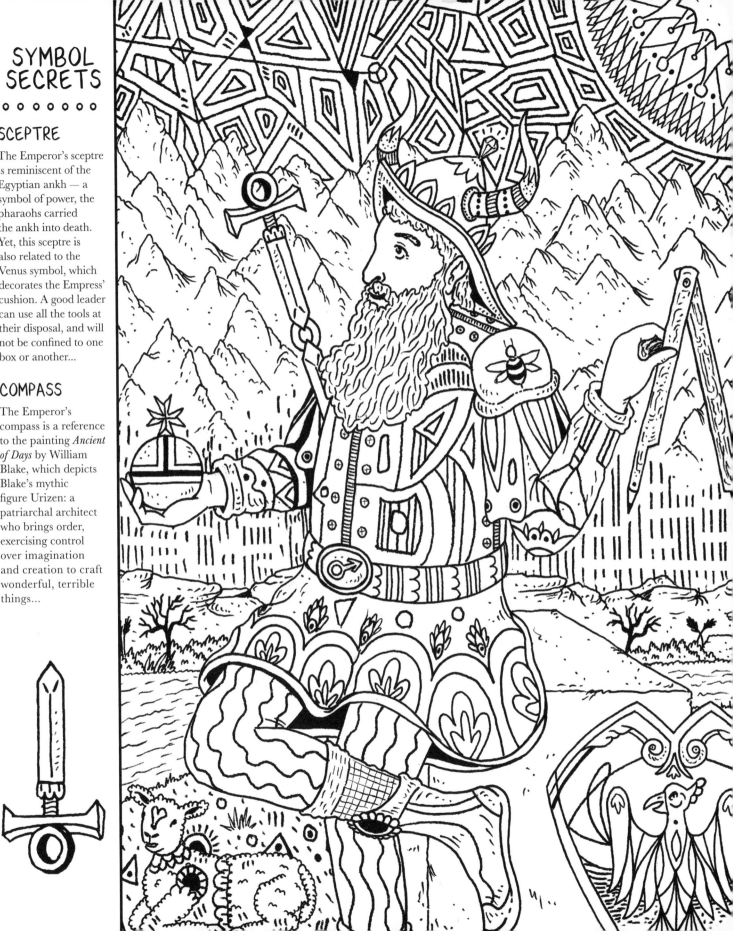

REFLECTIONS

What's a logical solution to a
problem you've been facing?

...

...

...

Do you identify more with order or chaos? Why? How can you incorporate more of
the other into your life?

...

...

PRACTICE

Imagine your life as a city — you are its architect. Group different aspects into different districts and neighbourhoods.
Is your childhood a playground, a school, or a forest? What does your adult life look like? Is your social life grouped
in one area, or spread out into different streets, one for each hobby?

Draw a map of your life-city here:

THE HIEROPHANT

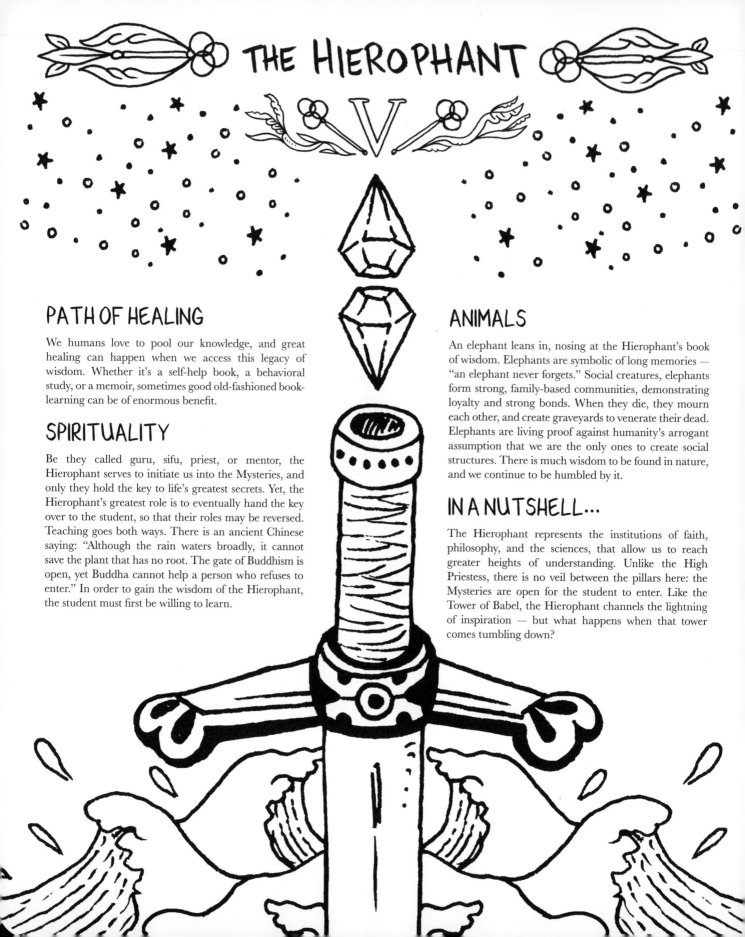

PATH OF HEALING

We humans love to pool our knowledge, and great healing can happen when we access this legacy of wisdom. Whether it's a self-help book, a behavioral study, or a memoir, sometimes good old-fashioned book-learning can be of enormous benefit.

SPIRITUALITY

Be they called guru, sifu, priest, or mentor, the Hierophant serves to initiate us into the Mysteries, and only they hold the key to life's greatest secrets. Yet, the Hierophant's greatest role is to eventually hand the key over to the student, so that their roles may be reversed. Teaching goes both ways. There is an ancient Chinese saying: "Although the rain waters broadly, it cannot save the plant that has no root. The gate of Buddhism is open, yet Buddha cannot help a person who refuses to enter." In order to gain the wisdom of the Hierophant, the student must first be willing to learn.

ANIMALS

An elephant leans in, nosing at the Hierophant's book of wisdom. Elephants are symbolic of long memories — "an elephant never forgets." Social creatures, elephants form strong, family-based communities, demonstrating loyalty and strong bonds. When they die, they mourn each other, and create graveyards to venerate their dead. Elephants are living proof against humanity's arrogant assumption that we are the only ones to create social structures. There is much wisdom to be found in nature, and we continue to be humbled by it.

IN A NUTSHELL...

The Hierophant represents the institutions of faith, philosophy, and the sciences, that allow us to reach greater heights of understanding. Unlike the High Priestess, there is no veil between the pillars here: the Mysteries are open for the student to enter. Like the Tower of Babel, the Hierophant channels the lightning of inspiration — but what happens when that tower comes tumbling down?

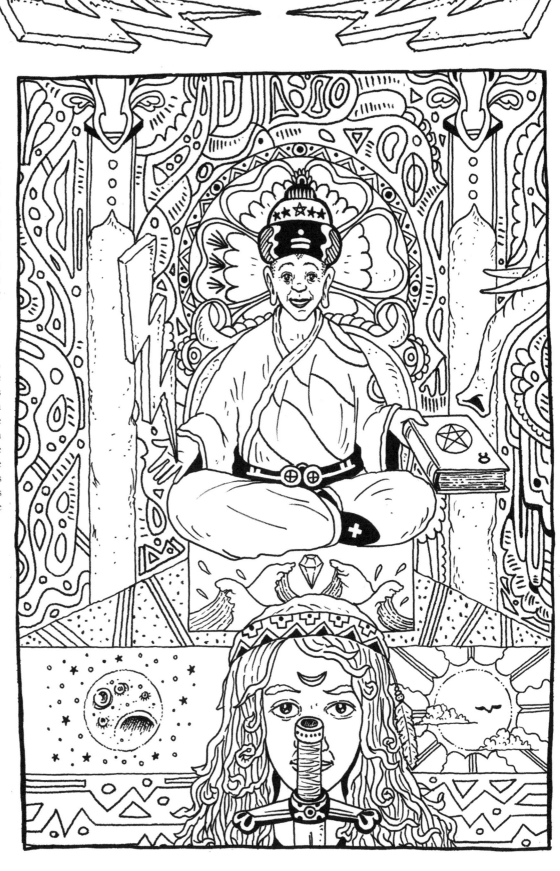

SYMBOL SECRETS

○ ○ ○ ○ ○ ○ ○

BOLT

In Kabbalah lore, when Eve bit into the fruit of knowledge, a bolt of lightning shot through the Tree of Life, creating an abyss between the top three spheres and the rest of reality. It is this bolt that the Hierophant wields, generating sparks of inspiration in their students; yet this is also the lightning that strikes the Tower later in the Major Arcana...

ISIS

In response to the *Thoth Tarot,* wherein Isis appears at the base of The Hierophant card, here Isis is at the forefront. We are now in the Age of Isis: the revival of the feminine in counterbalance with the masculine patriarchy that the Hierophant represents. A true system of education embraces all genders — and so, Isis shares the Hierophant's place in the foreground.

SYMBOLS

○ ○ ○ ○ ○ ○ ○

PILLARS
LOTUS
HEADDRESS
LIGHTNING
BOOK
KEYS
CROSS
SEAT
SUN
MOON
ISIS

REFLECTIONS

Have you ever had a teacher or mentor who really had an impact on your life? Write five things you learned from them here:

..

..

..

..

Is there a school of thought that you subscribe to? How has your relationship with it developed over time?

..

..

..

..

PRACTICE

Is there one truth you have learned that you would like to share with others? Imagine that you get the opportunity to teach a class on this truth or on a subject you're interested in or passionate about. How would you structure this class to really ensure that your students reached a greater understanding of this topic?

..

..

..

..

..

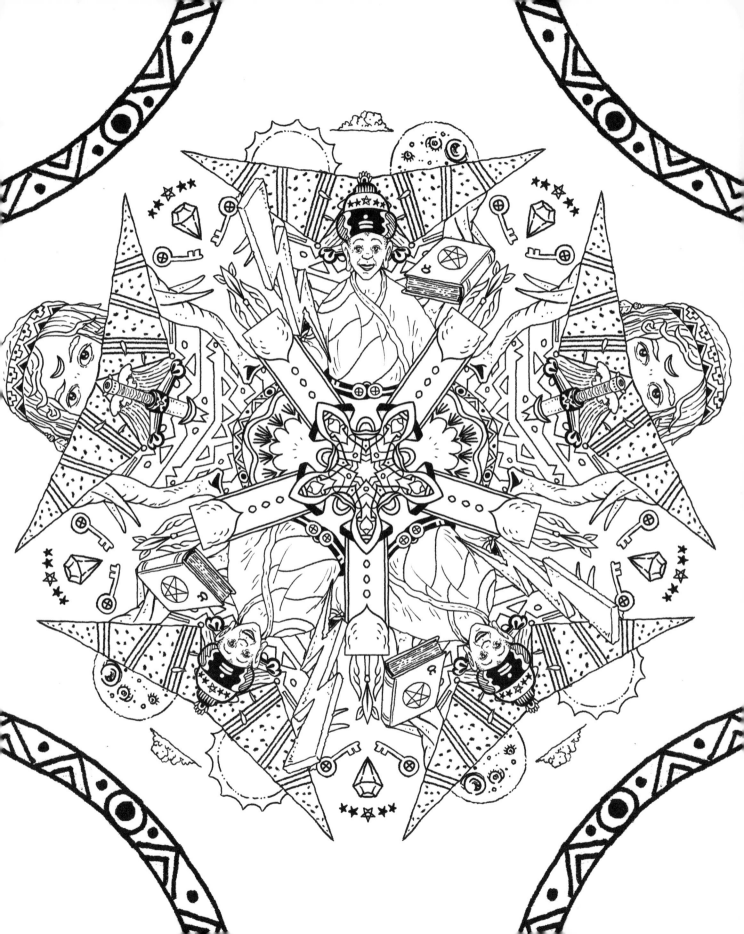

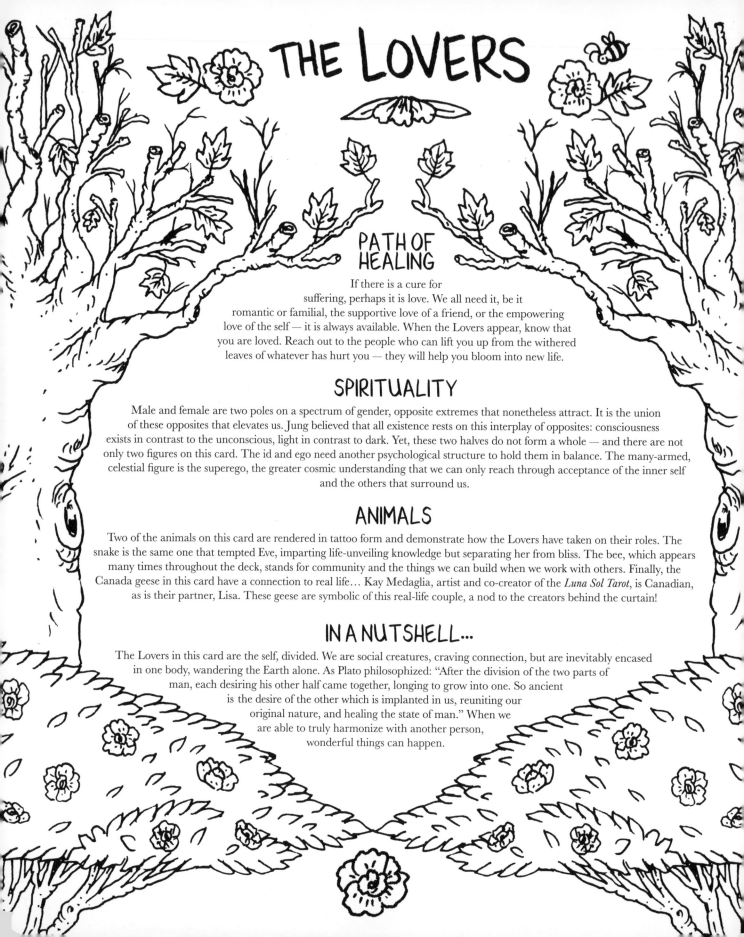

THE LOVERS

PATH OF HEALING

If there is a cure for
suffering, perhaps it is love. We all need it, be it
romantic or familial, the supportive love of a friend, or the empowering
love of the self — it is always available. When the Lovers appear, know that
you are loved. Reach out to the people who can lift you up from the withered
leaves of whatever has hurt you — they will help you bloom into new life.

SPIRITUALITY

Male and female are two poles on a spectrum of gender, opposite extremes that nonetheless attract. It is the union
of these opposites that elevates us. Jung believed that all existence rests on this interplay of opposites: consciousness
exists in contrast to the unconscious, light in contrast to dark. Yet, these two halves do not form a whole — and there are not
only two figures on this card. The id and ego need another psychological structure to hold them in balance. The many-armed,
celestial figure is the superego, the greater cosmic understanding that we can only reach through acceptance of the inner self
and the others that surround us.

ANIMALS

Two of the animals on this card are rendered in tattoo form and demonstrate how the Lovers have taken on their roles. The
snake is the same one that tempted Eve, imparting life-unveiling knowledge but separating her from bliss. The bee, which appears
many times throughout the deck, stands for community and the things we can build when we work with others. Finally, the
Canada geese in this card have a connection to real life… Kay Medaglia, artist and co-creator of the *Luna Sol Tarot*, is Canadian,
as is their partner, Lisa. These geese are symbolic of this real-life couple, a nod to the creators behind the curtain!

IN A NUTSHELL…

The Lovers in this card are the self, divided. We are social creatures, craving connection, but are inevitably encased
in one body, wandering the Earth alone. As Plato philosophized: "After the division of the two parts of
man, each desiring his other half came together, longing to grow into one. So ancient
is the desire of the other which is implanted in us, reuniting our
original nature, and healing the state of man." When we
are able to truly harmonize with another person,
wonderful things can happen.

SYMBOL SECRETS

DHARMA TRANSMISSION

We are connected to those we love by invisible strings. Relationships can transcend definition, and two people can reach higher wisdom just through each other. This is the Zen Buddhist idea of Dharma Transmission, a legacy of ideas that stretches across the twin voids of space and time. And in Buddhist tradition, the final reincarnation is female...

CELESTIAL ARMS

The many arms of the celestial figure reference depictions of Hindu gods. By their celestial nature, this figure is infinitely multi-faceted, and thus incomprehensible to mere mortals. Accordingly, this unknowable divinity's form is refracted in a way we *can* understand, the many arms making it clear that this figure is more than they appear.

SYMBOLS

o o o o o o o o

SUN
MULTIPLE ARMS
BEAM
MOUNTAIN
SPRING TREE
AUTUMN TREE
RIVER
BEE TATTOO
SNAKE TATTOO
CANADA GEESE

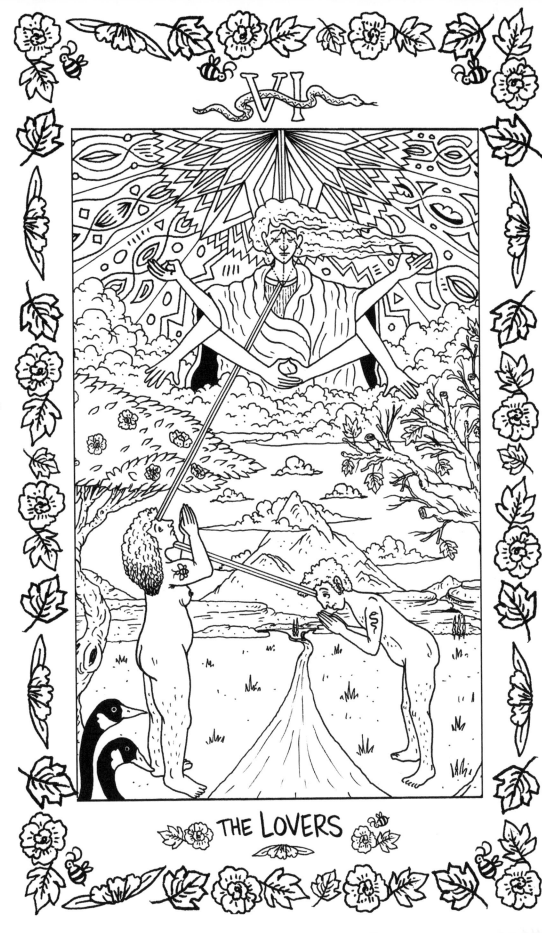

THE LOVERS

REFLECTIONS

What's the kindest thing anyone has ever done for you?

...

...

...

What's one great truth you have learned through love?

...

...

...

PRACTICE

Find a dead leaf, and a new blossom. Press them between the pages here:

The leaf is something inside you that has withered away — this could be an old hobby which has faded over time, or a youthful personality trait that has evolved in your maturity. The blossom is something new, a passion you've just discovered, or a new connection that has just bloomed.

Write down what each one means to you here, and how others have affected your growth:

...

...

...

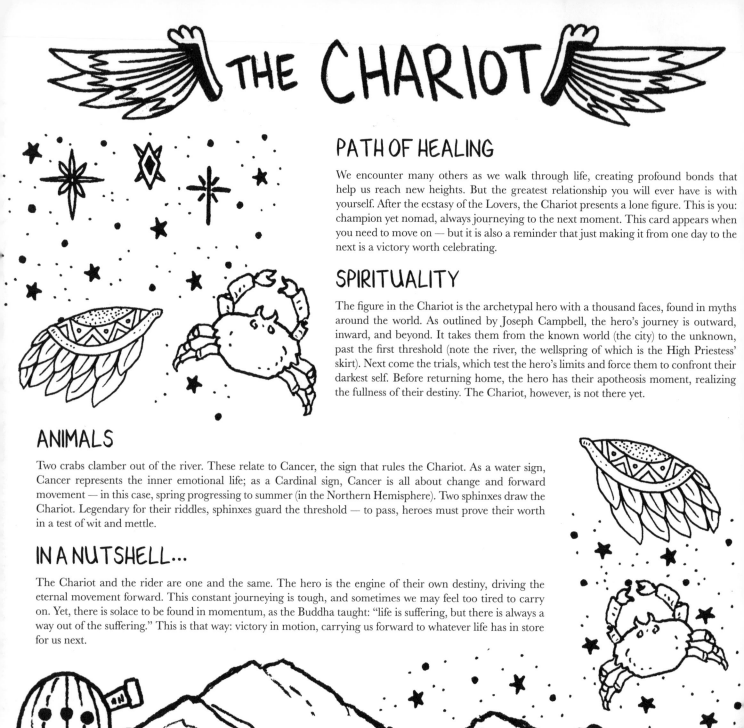

THE CHARIOT

PATH OF HEALING

We encounter many others as we walk through life, creating profound bonds that help us reach new heights. But the greatest relationship you will ever have is with yourself. After the ecstasy of the Lovers, the Chariot presents a lone figure. This is you: champion yet nomad, always journeying to the next moment. This card appears when you need to move on — but it is also a reminder that just making it from one day to the next is a victory worth celebrating.

SPIRITUALITY

The figure in the Chariot is the archetypal hero with a thousand faces, found in myths around the world. As outlined by Joseph Campbell, the hero's journey is outward, inward, and beyond. It takes them from the known world (the city) to the unknown, past the first threshold (note the river, the wellspring of which is the High Priestess' skirt). Next come the trials, which test the hero's limits and force them to confront their darkest self. Before returning home, the hero has their apotheosis moment, realizing the fullness of their destiny. The Chariot, however, is not there yet.

ANIMALS

Two crabs clamber out of the river. These relate to Cancer, the sign that rules the Chariot. As a water sign, Cancer represents the inner emotional life; as a Cardinal sign, Cancer is all about change and forward movement — in this case, spring progressing to summer (in the Northern Hemisphere). Two sphinxes draw the Chariot. Legendary for their riddles, sphinxes guard the threshold — to pass, heroes must prove their worth in a test of wit and mettle.

IN A NUTSHELL...

The Chariot and the rider are one and the same. The hero is the engine of their own destiny, driving the eternal movement forward. This constant journeying is tough, and sometimes we may feel too tired to carry on. Yet, there is solace to be found in momentum, as the Buddha taught: "life is suffering, but there is always a way out of the suffering." This is that way: victory in motion, carrying us forward to whatever life has in store for us next.

SYMBOL SECRETS

STARRY CANOPY

The Chariot's canopy is filled with stars. This signifies the lofty planes that the Chariot can reach, and the Mysteries beyond the High Priestess' veil, but it also pays homage to the ancient navigators, who let the stars be their guide. Actually, if you connect these stars like dots, you'll trace the constellation of Cancer...

FOUR PILLARS

The number four is significant and features twice on The Chariot card: there are four pillars holding up the canopy, and four corners to the square on the rider's chest. Any appearance of four in the tarot represents the four corners of the Earth — in this case, the distances to which the Chariot could travel.

SYMBOLS

∘ ∘ ∘ ∘ ∘ ∘ ∘ ∘

CANOPY
EYE
CITY
RIVER
HEADDRESS
CRESCENT MOONS
SQUARE
MANDALA
WINGS
GRAIL
DIAMOND

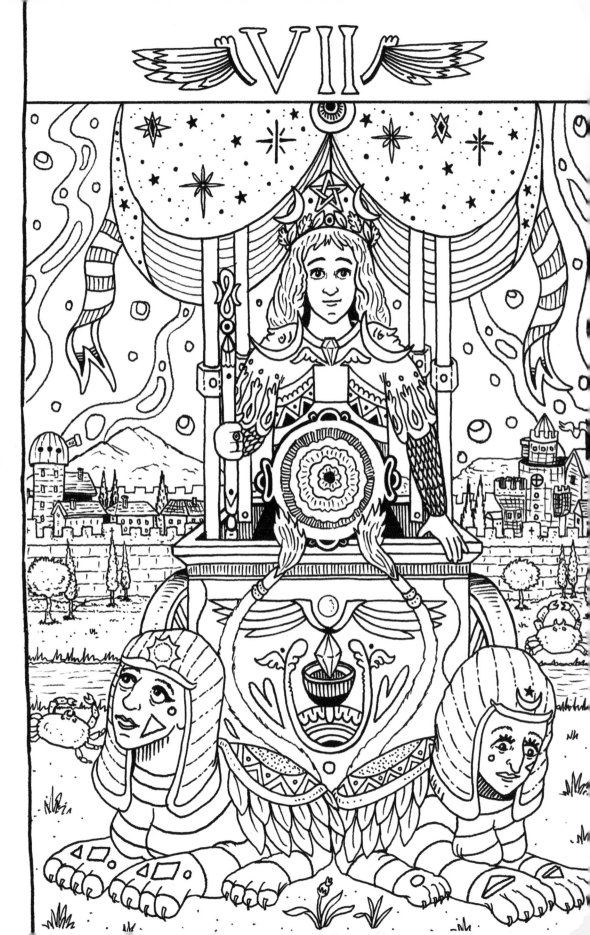

REFLECTIONS

What keeps you going when you feel like you can't carry on?

..
..
..
..

What stage of the hero's journey do you feel you're currently at?

..
..
..
..

PRACTICE

Challenge yourself to go somewhere new. Is there a place you've always meant to go, but never found the chance? It could also be a new step in your life's journey. Take this opportunity to plan out a route. What boundaries can you traverse? What obstacles can you navigate around? Visualizing a path is the first step to building it...

..
..
..
..
..
..

JUSTICE

PATH OF HEALING

The past and the present intersect here. Justice calls upon you to view yourself as a united whole, balancing the elements of your being and reconciling with your past self. Life presents us with many painful choices; how can we see the way ahead clearly when inner conflict clouds our vision? But if we accept ourselves as we truly are and cultivate a bedrock of internal integrity, we can approach these choices with honesty from a bedrock of internal integrity.

SPIRITUALITY

Justice herself is a symbol — she stands, carved from stone, outside courthouses and institutions of judgement. But where did this figure come from? We can trace her back to the Greek goddess Themis, the only one who could pass judgement on the gods and impose the divine laws that govern reality. The Romans transposed her into Iustitia, who became Lady Justice, outlasting the Roman Empire. Originally clear-sighted, a blindfold was added to her depictions in the 1500s — if she could not see whom she was judging, then Lady Justice would not be swayed by rank or circumstance. There is a difference, after all, between true justice and the law of the land...

ANIMALS

Cats have long been our companions, with evidence that they were domesticated around 12,000BC in Mesopotamia. The Ancient Egyptians considered them divine harbingers of luck. In China, Confucius wrote of the legend of the cat goddess Li Shou, who was instructed to watch over the world — but when she couldn't resist playing or sleeping in the sun, she asked for the responsibility to be given to humans instead. On this card, the watchful kitty sits at Justice's feet, still keeping an eye on things...

IN A NUTSHELL...

Our choices make us who we are: each decision, minor or monumental, is a step we take on our life's path. Regret is crippling because it is the ultimate form of inner conflict — if we cannot accept the decisions we've made, we cannot move forward. Once we have learned this lesson, and accepted our past, we can embrace the responsibility of the present. Every moment you are building yourself, and your future. So, embrace Justice's clear vision and certainty of action. Who do you want to become?

SYMBOL SECRETS

SWORD

Justice's sword allows her to cut to the heart of the matter, to the truth behind the veils of illusion — for without truth, how can we make a balanced judgement? True justice may sometimes be harsh, but it is always fair.

SCALES

Libra, another Cardinal sign, is the celestial scales. It was added to the zodiac by the Romans, who noted that during the Autumnal Equinox — when the days are held in balance — the sun passes through this constellation.

SYMBOLS

○ ○ ○ ○ ○ ○ ○ ○

DAY
NIGHT
PILLARS
VEIL
HEADDRESS
SWORD
SCALES
YIN & YANG
SEA
LIBRA

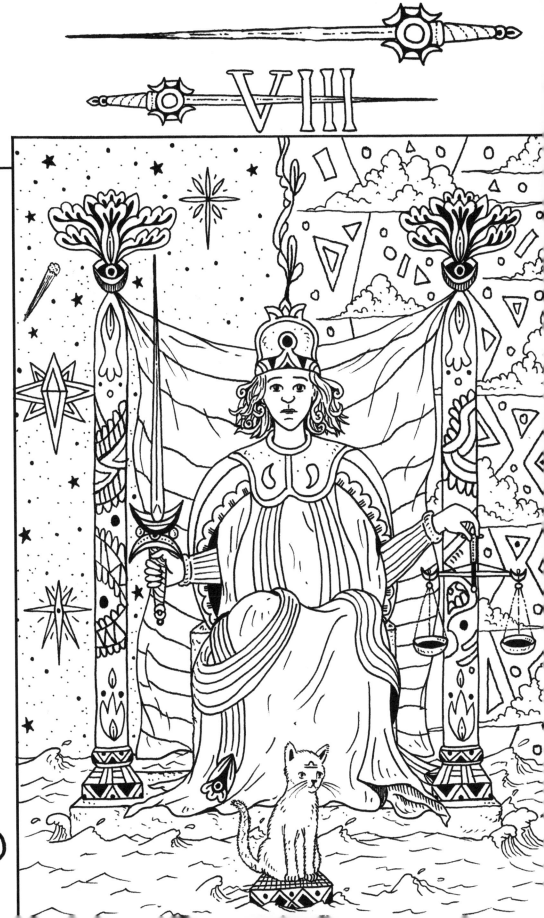

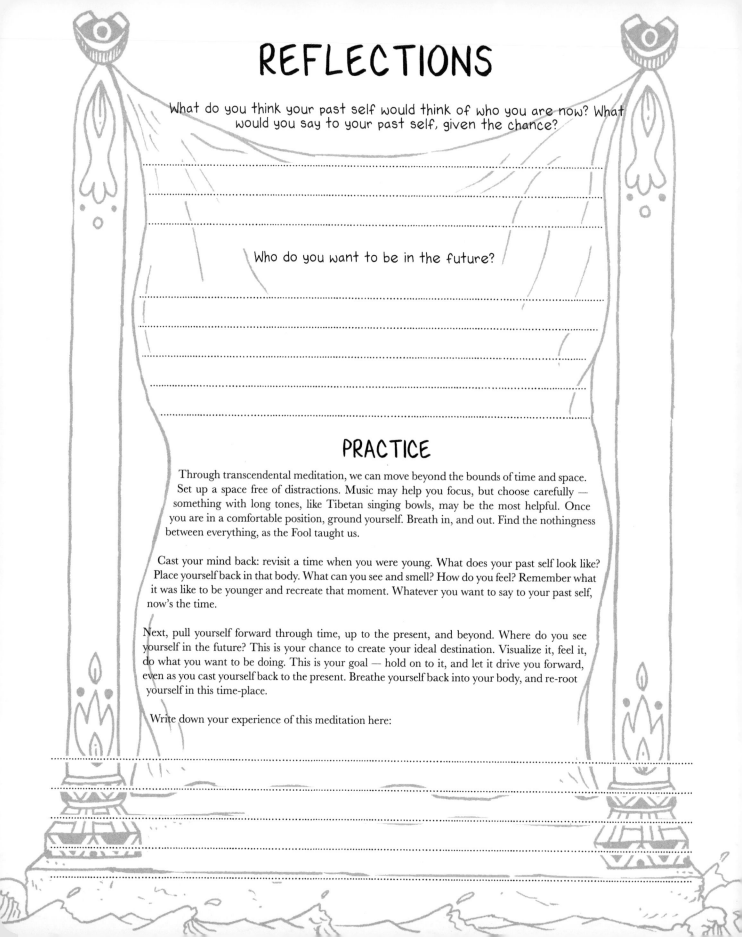

REFLECTIONS

What do you think your past self would think of who you are now? What would you say to your past self, given the chance?

..

..

..

Who do you want to be in the future?

..

..

..

..

PRACTICE

Through transcendental meditation, we can move beyond the bounds of time and space. Set up a space free of distractions. Music may help you focus, but choose carefully — something with long tones, like Tibetan singing bowls, may be the most helpful. Once you are in a comfortable position, ground yourself. Breath in, and out. Find the nothingness between everything, as the Fool taught us.

Cast your mind back: revisit a time when you were young. What does your past self look like? Place yourself back in that body. What can you see and smell? How do you feel? Remember what it was like to be younger and recreate that moment. Whatever you want to say to your past self, now's the time.

Next, pull yourself forward through time, up to the present, and beyond. Where do you see yourself in the future? This is your chance to create your ideal destination. Visualize it, feel it, do what you want to be doing. This is your goal — hold on to it, and let it drive you forward, even as you cast yourself back to the present. Breathe yourself back into your body, and re-root yourself in this time-place.

Write down your experience of this meditation here:

..

..

..

..

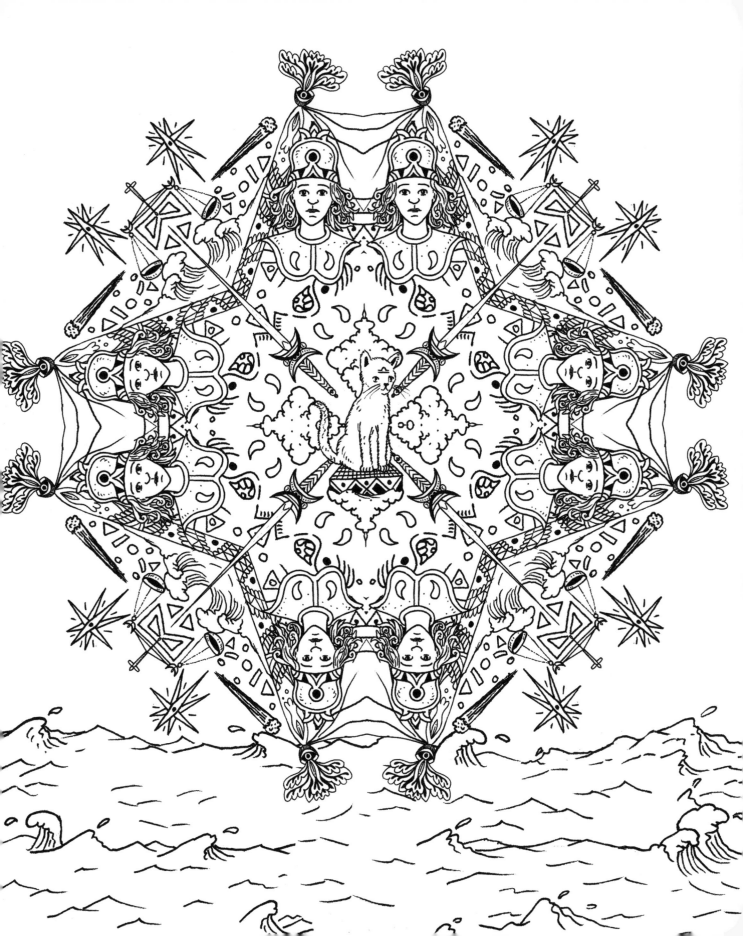

THE HERMIT

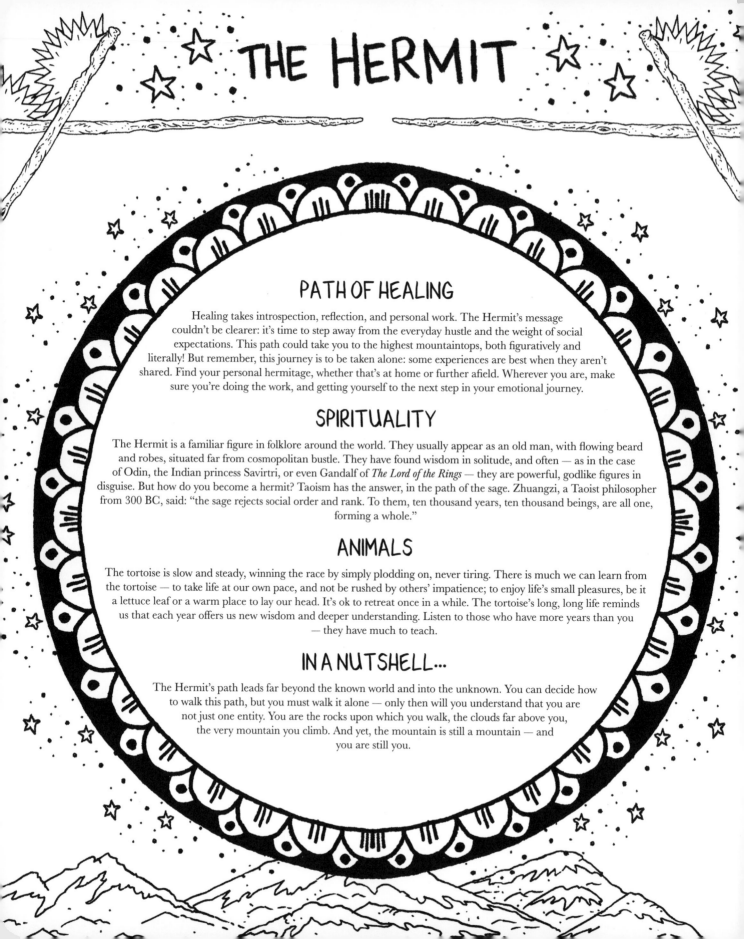

PATH OF HEALING

Healing takes introspection, reflection, and personal work. The Hermit's message couldn't be clearer: it's time to step away from the everyday hustle and the weight of social expectations. This path could take you to the highest mountaintops, both figuratively and literally! But remember, this journey is to be taken alone: some experiences are best when they aren't shared. Find your personal hermitage, whether that's at home or further afield. Wherever you are, make sure you're doing the work, and getting yourself to the next step in your emotional journey.

SPIRITUALITY

The Hermit is a familiar figure in folklore around the world. They usually appear as an old man, with flowing beard and robes, situated far from cosmopolitan bustle. They have found wisdom in solitude, and often — as in the case of Odin, the Indian princess Savirtri, or even Gandalf of *The Lord of the Rings* — they are powerful, godlike figures in disguise. But how do you become a hermit? Taoism has the answer, in the path of the sage. Zhuangzi, a Taoist philosopher from 300 BC, said: "the sage rejects social order and rank. To them, ten thousand years, ten thousand beings, are all one, forming a whole."

ANIMALS

The tortoise is slow and steady, winning the race by simply plodding on, never tiring. There is much we can learn from the tortoise — to take life at our own pace, and not be rushed by others' impatience; to enjoy life's small pleasures, be it a lettuce leaf or a warm place to lay our head. It's ok to retreat once in a while. The tortoise's long, long life reminds us that each year offers us new wisdom and deeper understanding. Listen to those who have more years than you — they have much to teach.

IN A NUTSHELL...

The Hermit's path leads far beyond the known world and into the unknown. You can decide how to walk this path, but you must walk it alone — only then will you understand that you are not just one entity. You are the rocks upon which you walk, the clouds far above you, the very mountain you climb. And yet, the mountain is still a mountain — and you are still you.

SYMBOL SECRETS

MOUNTAIN

The Chinese Zen master Qingyuan Weixin said: "Before I studied Zen, I saw mountains as mountains, and rivers as rivers. When I learned, I saw that mountains are not mountains, and rivers are not rivers. Now, I see mountains once again as mountains, and rivers once again as rivers." At first, we only see the world as it appears. Then, we learn that nothing in the material world is separate, and we are all part of the same greater whole. Finally, we understand that no matter *how* we see it, a mountain is still a mountain.

LANTERN

The lantern is a symbol of light in the dark, an object we use to reach higher knowledge, like the Magician's books or the Hierophant's key. Yet, look closer: true light, true wisdom, comes not from without, but from within...

SYMBOLS

∘ ∘ ∘ ∘ ∘ ∘ ∘ ∘ ∘ ∘

MOON
SHAVED HEAD
ROBE
BUDDHA SMILE
LANTERN
LIGHT BURST
STAFF
MOUNTAIN

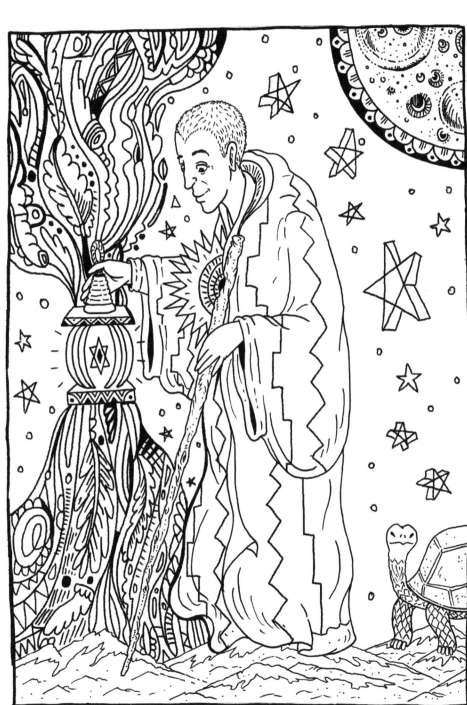

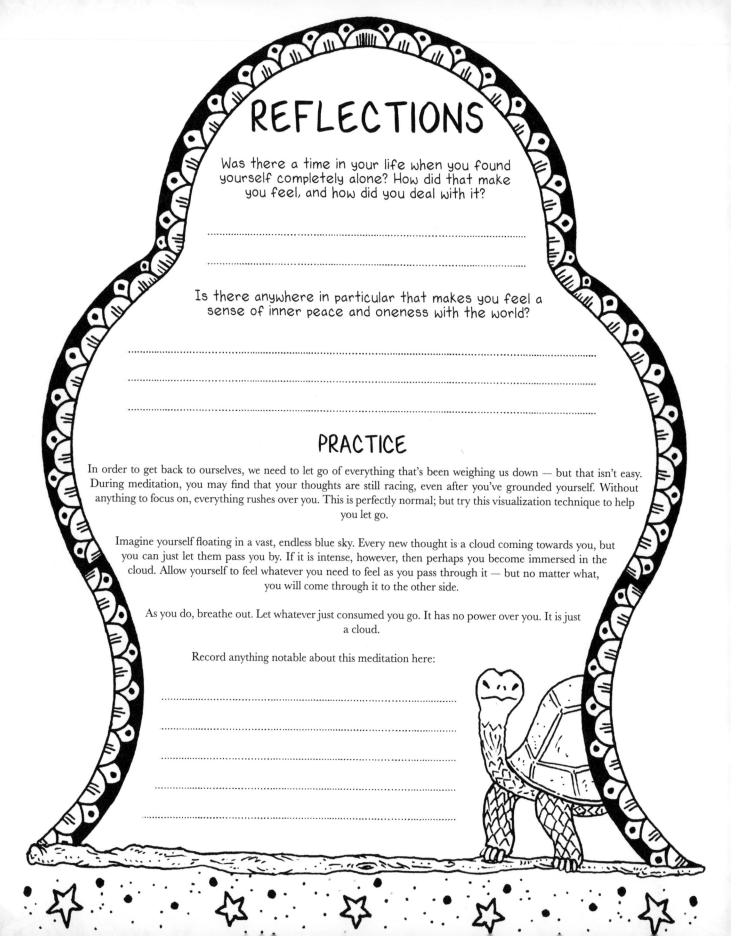

REFLECTIONS

Was there a time in your life when you found yourself completely alone? How did that make you feel, and how did you deal with it?

..

..

Is there anywhere in particular that makes you feel a sense of inner peace and oneness with the world?

..

..

..

PRACTICE

In order to get back to ourselves, we need to let go of everything that's been weighing us down — but that isn't easy. During meditation, you may find that your thoughts are still racing, even after you've grounded yourself. Without anything to focus on, everything rushes over you. This is perfectly normal; but try this visualization technique to help you let go.

Imagine yourself floating in a vast, endless blue sky. Every new thought is a cloud coming towards you, but you can just let them pass you by. If it is intense, however, then perhaps you become immersed in the cloud. Allow yourself to feel whatever you need to feel as you pass through it — but no matter what, you will come through it to the other side.

As you do, breathe out. Let whatever just consumed you go. It has no power over you. It is just a cloud.

Record anything notable about this meditation here:

..

..

..

..

WHEEL of FORTUNE

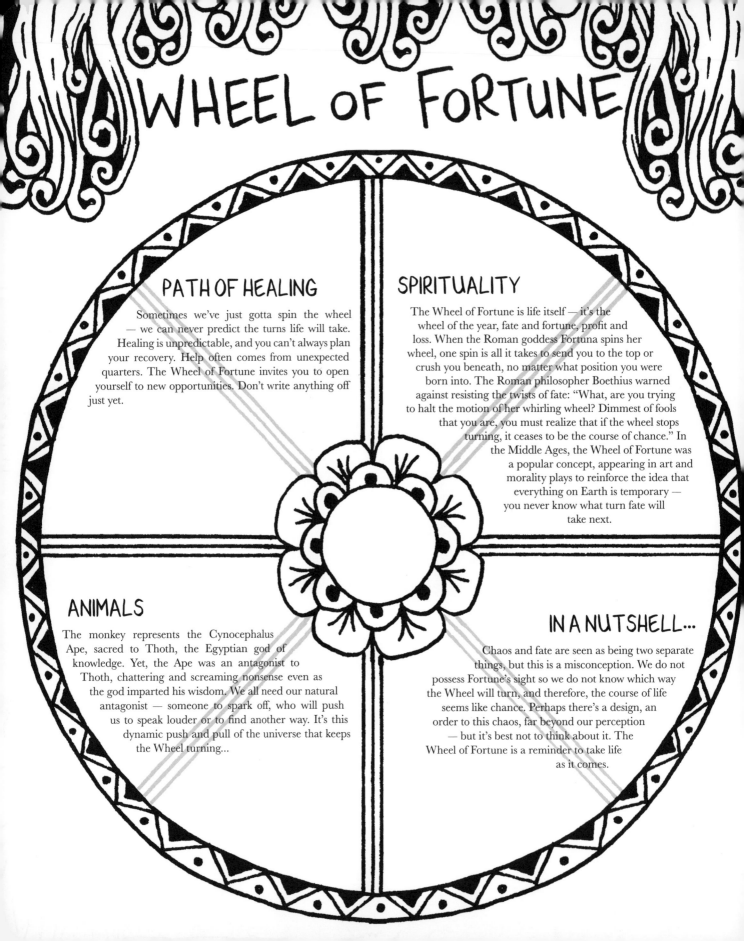

PATH OF HEALING

Sometimes we've just gotta spin the wheel — we can never predict the turns life will take. Healing is unpredictable, and you can't always plan your recovery. Help often comes from unexpected quarters. The Wheel of Fortune invites you to open yourself to new opportunities. Don't write anything off just yet.

SPIRITUALITY

The Wheel of Fortune is life itself — it's the wheel of the year, fate and fortune, profit and loss. When the Roman goddess Fortuna spins her wheel, one spin is all it takes to send you to the top or crush you beneath, no matter what position you were born into. The Roman philosopher Boethius warned against resisting the twists of fate: "What, are you trying to halt the motion of her whirling wheel? Dimmest of fools that you are, you must realize that if the wheel stops turning, it ceases to be the course of chance." In the Middle Ages, the Wheel of Fortune was a popular concept, appearing in art and morality plays to reinforce the idea that everything on Earth is temporary — you never know what turn fate will take next.

ANIMALS

The monkey represents the Cynocephalus Ape, sacred to Thoth, the Egyptian god of knowledge. Yet, the Ape was an antagonist to Thoth, chattering and screaming nonsense even as the god imparted his wisdom. We all need our natural antagonist — someone to spark off, who will push us to speak louder or to find another way. It's this dynamic push and pull of the universe that keeps the Wheel turning...

IN A NUTSHELL...

Chaos and fate are seen as being two separate things, but this is a misconception. We do not possess Fortune's sight so we do not know which way the Wheel will turn, and therefore, the course of life seems like chance. Perhaps there's a design, an order to this chaos, far beyond our perception — but it's best not to think about it. The Wheel of Fortune is a reminder to take life as it comes.

SYMBOL SECRETS

FACES

Here we see a human-like head, an eagle, a bull, and a lion. These figures represent the fixed signs of the zodiac, and also appear in the biblical Book of Revelation. When they appear in the tarot, they symbolize the four corners of the Earth.

ANUBIS

Anubis appears on the Wheel. The god of death, Anubis is connected in the tarot with the Greek god Hermes, who guided souls to the Underworld. This is just one of the many outcomes that the Wheel can bring about...

SYMBOLS

∘ ∘ ∘ ∘ ∘ ∘ ∘ ∘

SPHINX
PENTAGRAM
SWORD
FIRE TAIL
HUMAN
EAGLE
OX
LION
CYNOCEPHALUS
BOOKS
WHEEL
SUN
MOON
T
A
R
O
YIN & YANG

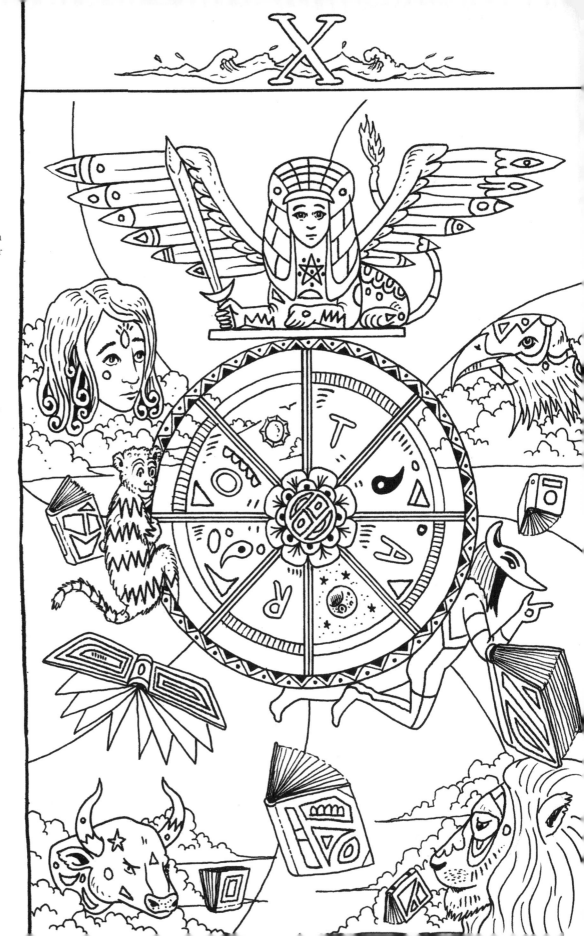

REFLECTIONS

Have you ever felt tossed about by fate?

...

...

...

...

Which part of the Wheel do you feel you're currently on?

...

...

...

...

PRACTICE

Every once in a while, we have to spin the Wheel of Fortune for ourselves. Is there something you've been deliberating over doing? A chance you're not sure whether you're willing to take? Even if it's something small like changing up your style to incorporate bolder colors, write down what's standing in your way. How does it look on paper? Can you find a way around it — or is the barrier really just in your mind?

...

...

...

...

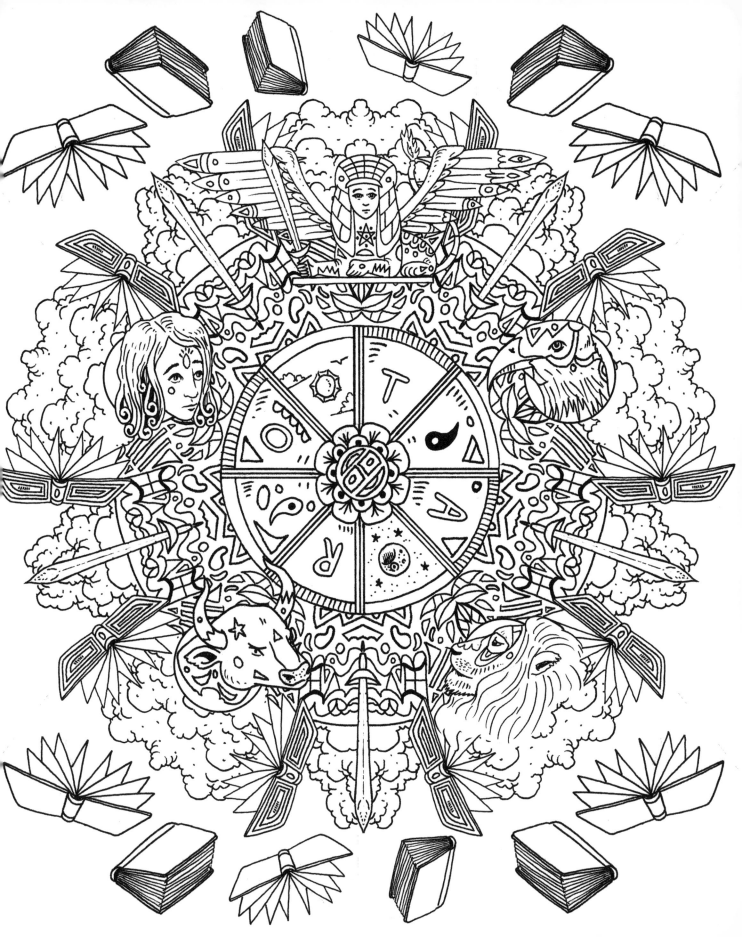

STRENGTH

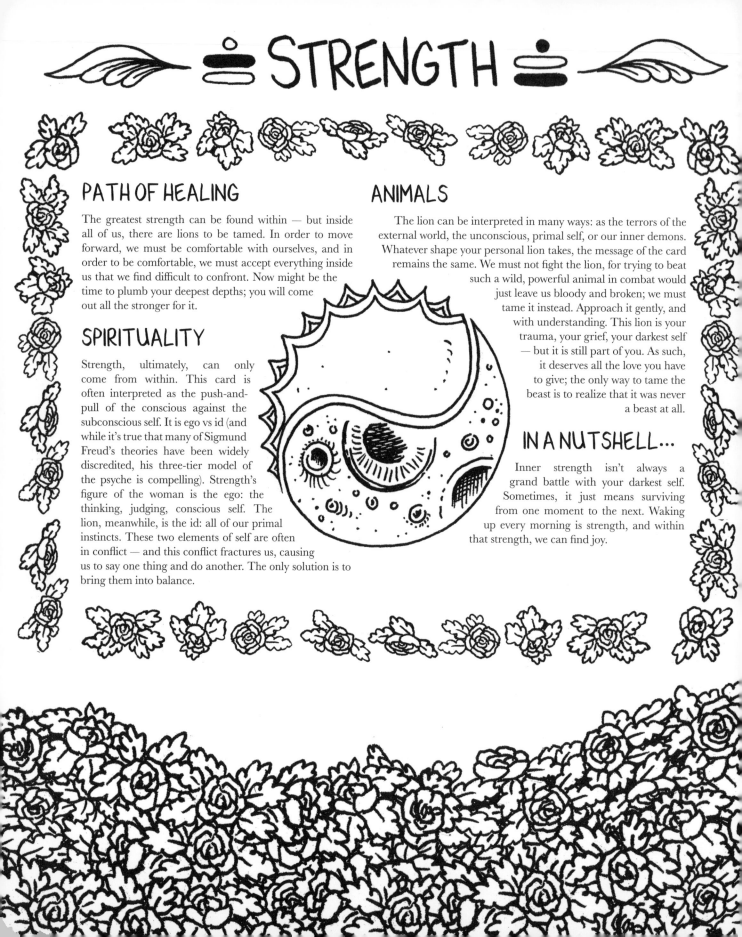

PATH OF HEALING

The greatest strength can be found within — but inside all of us, there are lions to be tamed. In order to move forward, we must be comfortable with ourselves, and in order to be comfortable, we must accept everything inside us that we find difficult to confront. Now might be the time to plumb your deepest depths; you will come out all the stronger for it.

SPIRITUALITY

Strength, ultimately, can only come from within. This card is often interpreted as the push-and-pull of the conscious against the subconscious self. It is ego vs id (and while it's true that many of Sigmund Freud's theories have been widely discredited, his three-tier model of the psyche is compelling). Strength's figure of the woman is the ego: the thinking, judging, conscious self. The lion, meanwhile, is the id: all of our primal instincts. These two elements of self are often in conflict — and this conflict fractures us, causing us to say one thing and do another. The only solution is to bring them into balance.

ANIMALS

The lion can be interpreted in many ways: as the terrors of the external world, the unconscious, primal self, or our inner demons. Whatever shape your personal lion takes, the message of the card remains the same. We must not fight the lion, for trying to beat such a wild, powerful animal in combat would just leave us bloody and broken; we must tame it instead. Approach it gently, and with understanding. This lion is your trauma, your grief, your darkest self — but it is still part of you. As such, it deserves all the love you have to give; the only way to tame the beast is to realize that it was never a beast at all.

IN A NUTSHELL...

Inner strength isn't always a grand battle with your darkest self. Sometimes, it just means surviving from one moment to the next. Waking up every morning is strength, and within that strength, we can find joy.

SYMBOL SECRETS

CONTRADICTION

Here, the sun and the moon have come together as one. This is the Yin and Yang completely in balance, representing the integrated self. We all contain contradictions; the important thing is not eradication of these elements of self, but the acceptance of them. As Walt Whitman said, "Do I contradict myself? Very well then, I contradict myself. I am large, I contain multitudes."

MAYAN ⚊

This is the symbol for 11 in Mayan numerology. While the *Rider-Waite-Smith Tarot* features Strength as number VIII, and Justice as XI, the earlier *Marseille Tarot* (and Aleister Crowley's *Thoth* deck) has these positions reversed. As Liminal11 was founded in the creation of the *Luna Sol Tarot*, we chose our eleventh card carefully. Strength, with its themes of self-development, was central to the *Luna Sol*, and to our lives. It had to be number 11.

SYMBOLS

o o o o o o o o o o

MAYAN ⚊
SUN
MOON
MOUNTAIN
INFINITY SYMBOL
WREATHS
YIN & YANG
GRASS

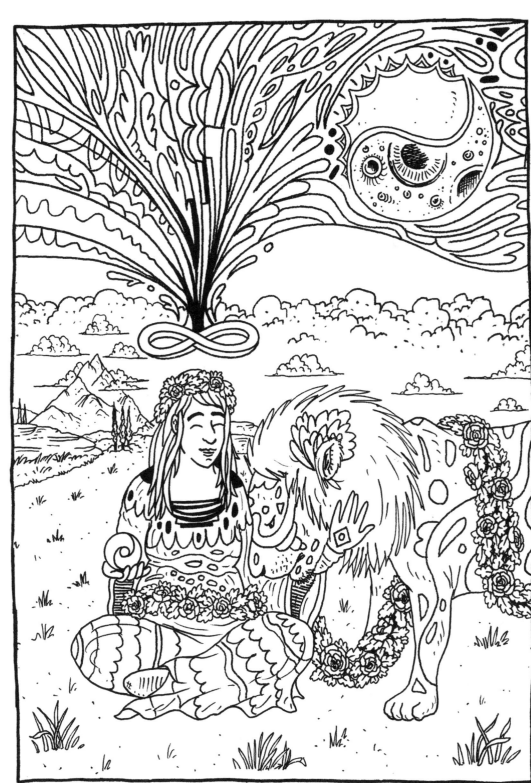

REFLECTIONS

Was there a time in your life when you had to rely on your inner strength? What did you learn about yourself in the process?

...

...

...

...

We all have things we live for, that get us through the day. What are yours?

...

...

...

...

PRACTICE

Self-love is the most important thing to learn, and one of the hardest things to teach. Write down five things you find difficult about yourself. Then, imagine that these were things you loved about someone else. How would you compliment that person on these aspects?

E.g.: "I'm too impulsive, I rush in." This could become "you're so bold; you take the initiative." Or "I overthink things" could be "you are self-reflective and consider every angle."

Once you've turned your insecurities into compliments, write them down on post-its and place them around your mirror. Read them aloud each morning. After a week, record how this changed your outlook on yourself:

...

...

...

...

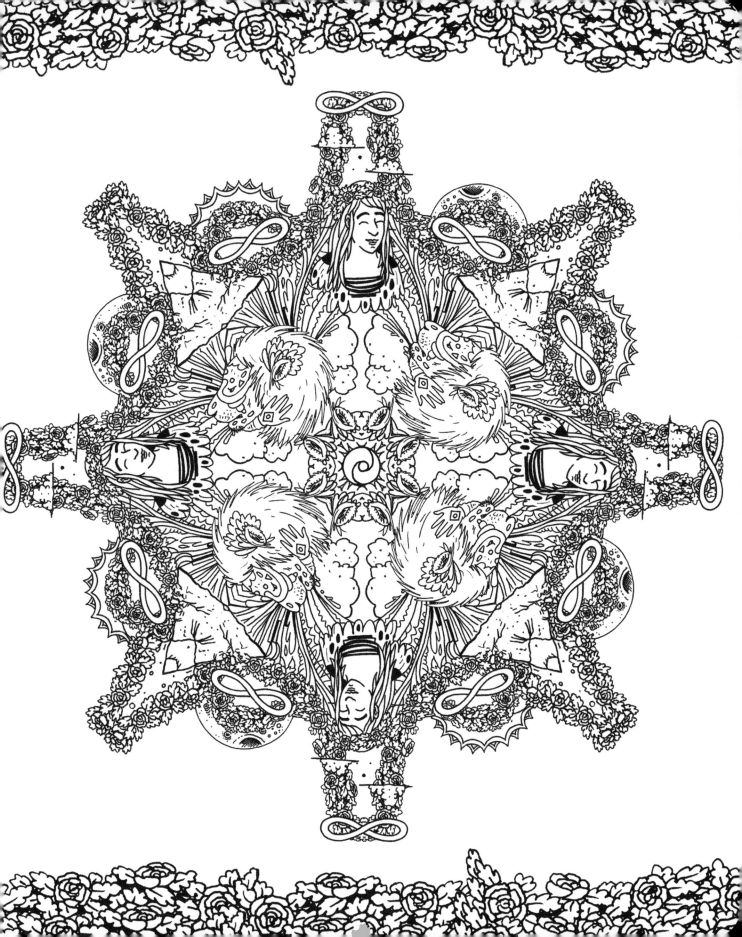

THE HANGED ONE

PATH OF HEALING

Sometimes the best way to move forward is to stand still. The Hanged One is static. When this card appears, you may be facing a difficult moment that you want to get out of as soon as possible. But what can you learn from this moment? Are you making assumptions? What happens if you force yourself to see things from a different angle? Perhaps the answer you've been waiting for has been here all along...

SPIRITUALITY

This is Odin at the base of Yggdrasil, the World Tree. Odin sacrificed himself and drank from the fountain of wisdom; through his suffering, he gained vast magickal knowledge, discovering how to read the runes and elevating his god status. This experience became a core part of Norse philosophy, as expressed in the poem *Hamaval*: "I know that I hung, on a windy tree, for all of nine nights, wounded with a spear, and given to Óðinn, myself to myself, on that tree, which no man knows, from what roots it runs." This parable teaches us that suffering can lead to great wisdom — not in spite of the suffering, but because of what it teaches us.

ANIMALS

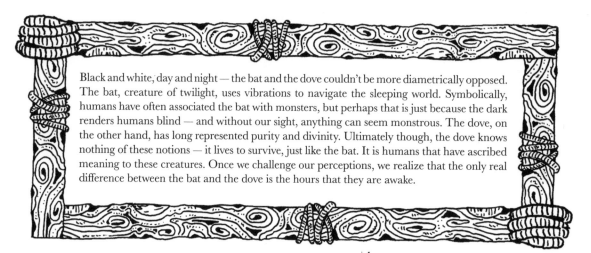

Black and white, day and night — the bat and the dove couldn't be more diametrically opposed. The bat, creature of twilight, uses vibrations to navigate the sleeping world. Symbolically, humans have often associated the bat with monsters, but perhaps that is just because the dark renders humans blind — and without our sight, anything can seem monstrous. The dove, on the other hand, has long represented purity and divinity. Ultimately though, the dove knows nothing of these notions — it lives to survive, just like the bat. It is humans that have ascribed meaning to these creatures. Once we challenge our perceptions, we realize that the only real difference between the bat and the dove is the hours that they are awake.

IN A NUTSHELL...

The Hanged One is about subversion — flipping your perception upside down while standing still. This may be painful, but all pain is a lesson waiting to be learned. Stay grounded in whatever roots you to this world, and you will find enlightenment in this moment.

SYMBOL SECRETS

○ ○ ○ ○ ○ ○ ○

BIRCH

"One of the seven sacred Celtic trees, Birch symbolizes new beginnings and birth." (Fez Inkright, *Folk Magic and Healing*) The Hanged One is suspended from three birch boughs — each from a different stage in the tree's life cycle — rooting them to nature and the source of all life that can be considered Tao. Lao Tzu said: "One who is firmly planted in Tao cannot be uprooted. One who holds fast to Tao cannot be taken away from it."

POSE

The Hanged One's pose is reminiscent of the number four, harkening back to the Emperor and inviting in all four corners of the world. In this instance, however, it is the left foot that is bent instead of the right (as in the *Rider-Waite-Smith* deck). This denotes unconscious choice: often these moments are moments of sacrifice, or perhaps your world has been upended in a way you never would have chosen. It's not how we got here that matters but what we make of these opportunities that will show us who we are.

SYMBOLS

○ ○ ○ ○ ○ ○ ○ ○ ○

ROPE
TREES
CRESCENTS
HALO
DROPLETS
BAT
DOVE
THE NUMBER FOUR

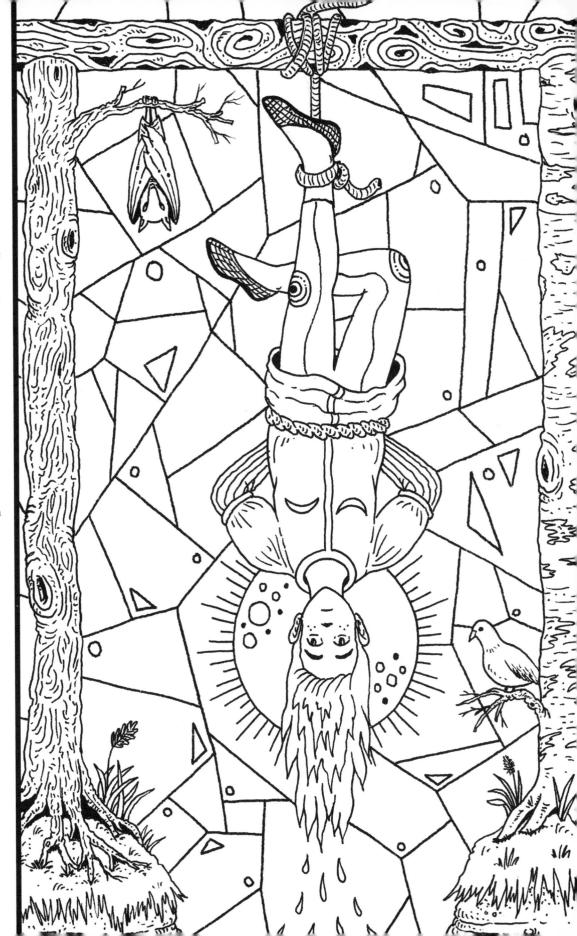

REFLECTIONS

What about this moment is causing you discomfort?
What are you learning from this discomfort?

...
...
...
...

Pick a situation you've experienced, or an event in history. How would this event
have played out differently if some roles had been reversed?

...
...
...
...

PRACTICE

Pick something that seems set in stone. This could be a universally accepted perception; a way in which we relate to others; or some fundamental truth from your own life. Then, ask yourself 'why' twice. First: why is this perception universally accepted? Then, once you've answered that question, ask yourself why you explained it the way you did.

What does this line of questioning reveal about the 'truth' you chose? Does it erode it, or reinforce it?

...
...
...
...
...

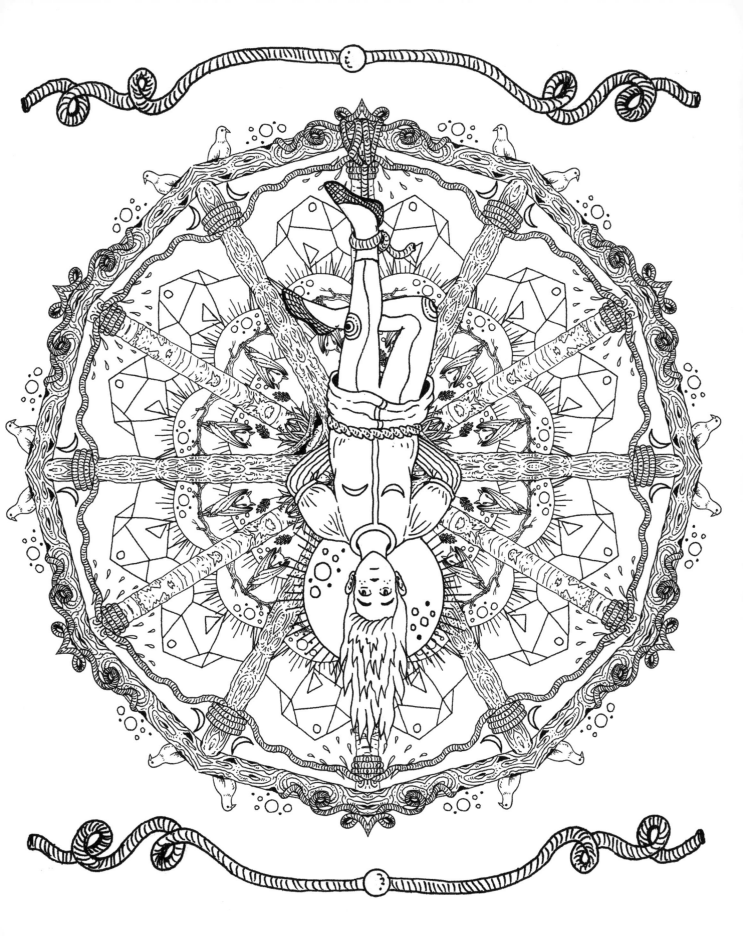

DEATH

PATH OF HEALING

Grief forces us to remain in the past, before the thing we are mourning was taken from us. Grief is not linear — it cares not for the march of time. When the Death card appears to you, you exist here. The only way to move on is to accept this ending. Nothing lasts forever — and nor should it, for if nothing ends, how can anything new begin? And while you carry your memories with you, how can anything ever truly be lost?

SPIRITUALITY

How do we conceive of Death? While each culture approaches it differently, there are parallels. Maori people perform *tuku*, a ceremony that helps to free the spirit from the body so it can find its way to *marae* (the spiritual meeting place). Hindus believe in reincarnation, and so Hindi death rites can be almost celebratory, as the soul has progressed to the next step in its great journey. Buddhist rites fulfil a similar purpose: chanting and caring for the body is thought to ensure a happy rebirth. In these cultures, and many others, we can see the concept of death and life being intertwined. There is an understanding that death is part of a bigger picture: it is inevitable, and essential to life.

ANIMALS

In front of the skeleton is a catfish, which is connected to the Hebrew letter Nun — and Nun's position on the Kabbalah Tree of Life is also where Death resides. This fish is also reminiscent of a Tiktaalik, the primordial fish that was the evolutionary basis for many vertebrate life forms, from amphibians, to birds, to humans. As such, it can be considered a synonym for birth, as it is the origin point for so much life on Earth. On Death's right is a snakeskin, shed and discarded. This is death and birth in action: the snake has sloughed off its youth, symbolic of the self that deconstructs and reconstructs as we age. Again, we also see a bee, the symbol for death in some cultures. There is a Celtic tradition, however, that persisted into the Middle Ages: people would "tell the bees" of all important events, especially births and deaths, and this was thought to bring good luck.

IN A NUTSHELL...

Death is not the opposite of life, but of birth: life encompasses, and is sustained by, both. While we celebrate our birth with each passing year, death hangs over us like a shadow. Ignoring death only increases its power: it is a form of denial. Yet, Jung argued that birth and death were part of the same curve. Perhaps, instead, we should face and accept death, and learn to see the beauty in the flowers that grow in death's wake. "When we do not fear death, it has no power over us," said Lao Tzu. After all, it is the finiteness of life that makes it worth living. The sun can only rise if it has previously set — but it will always rise again.

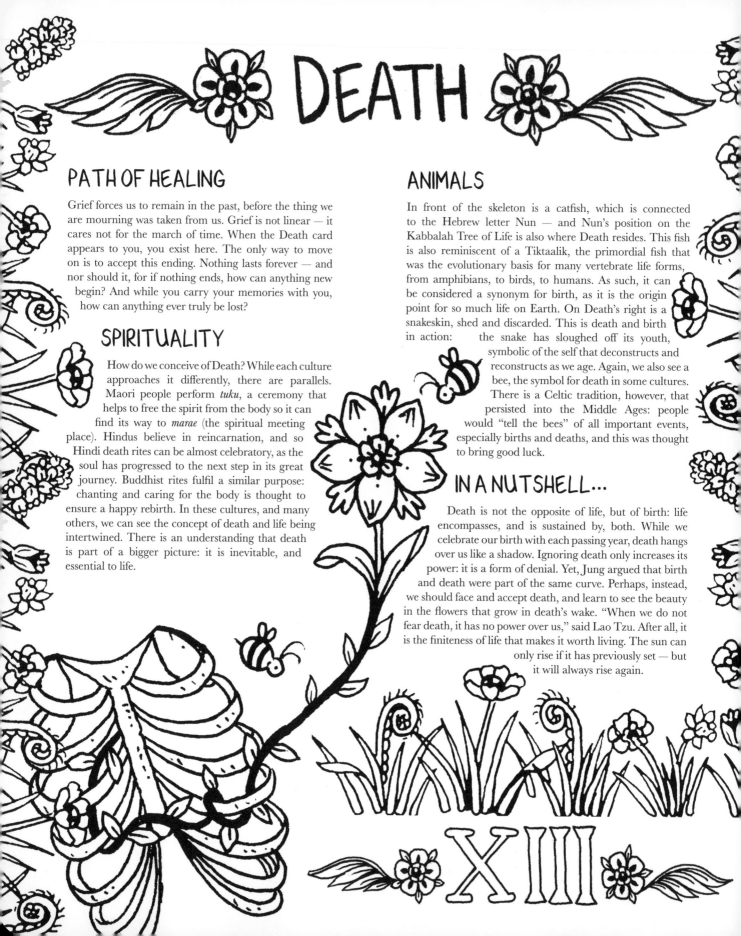

XIII

SYMBOL SECRETS

∘ ∘ ∘ ∘ ∘ ∘ ∘ ∘

FLOWER

A flower grows out of
Death's skeletal ribcage,
and isn't that just the
whole card in a nutshell?
Death is part of the life
cycle; without it, we could
not have more life. Death
literally feeds life, giving
nutrients to the soil, from
which plants grow to feed
the animals… and on and
on it goes, forever.

SCYTHE

In Europe, Death was first
depicted with a scythe
in the 14th century — in
the midst of the Plague.
The first of its kind, this
pandemic forced people
to confront death on a
daily basis, and so it was
personified in European art
as a reaper, the scythe its
grim tool of harvest. And
yet, harvest is the perfect
euphemism for death,
as the harvest feeds and
sustains us. The scythe's
shape is also reminiscent
of the crescent moon,
connecting this card to the
High Priestess, whose veil is
the ultimate threshold.

SYMBOLS

∘ ∘ ∘ ∘ ∘ ∘ ∘ ∘

MOON
BEE
FLOWER
SUN
RIVER
SNAKESKIN
SCYTHE
CYPRESS TREES

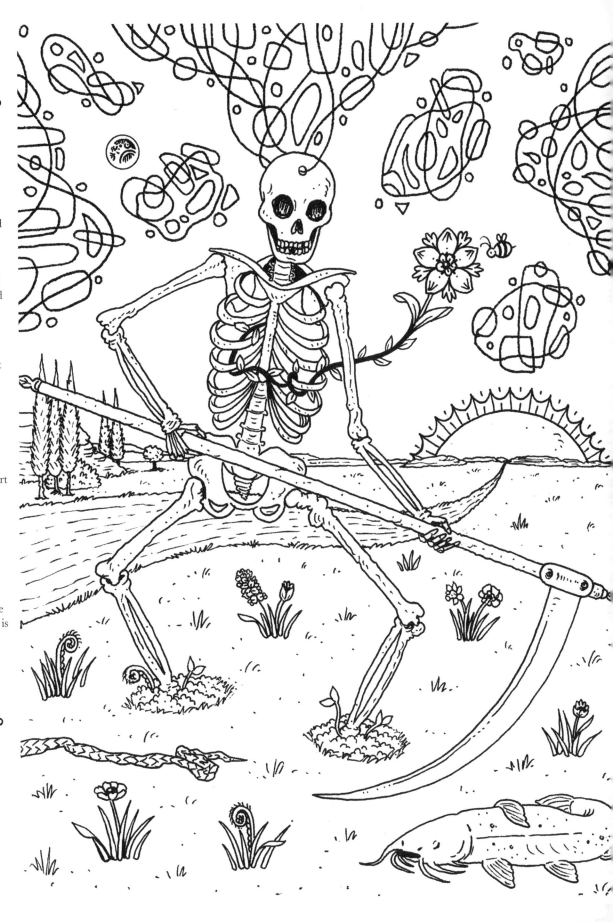

REFLECTIONS

If you knew this was your last day on Earth, how would you spend your time?

...

...

...

...

...

What's your relationship with Death like?

...

...

...

...

PRACTICE

If you can, go out into nature. The best way to contemplate Death is to immerse yourself in life. What season is it? What can you see that is dying? How is it sustaining the life around it? Sit for a while on a fallen log. Quiet your thoughts, open your senses. What parts of the life cycle are evident here? Consider your place within this cycle. How are you helping to feed the life around you?

Record anything you find notable about the experience here:

...

...

...

...

...

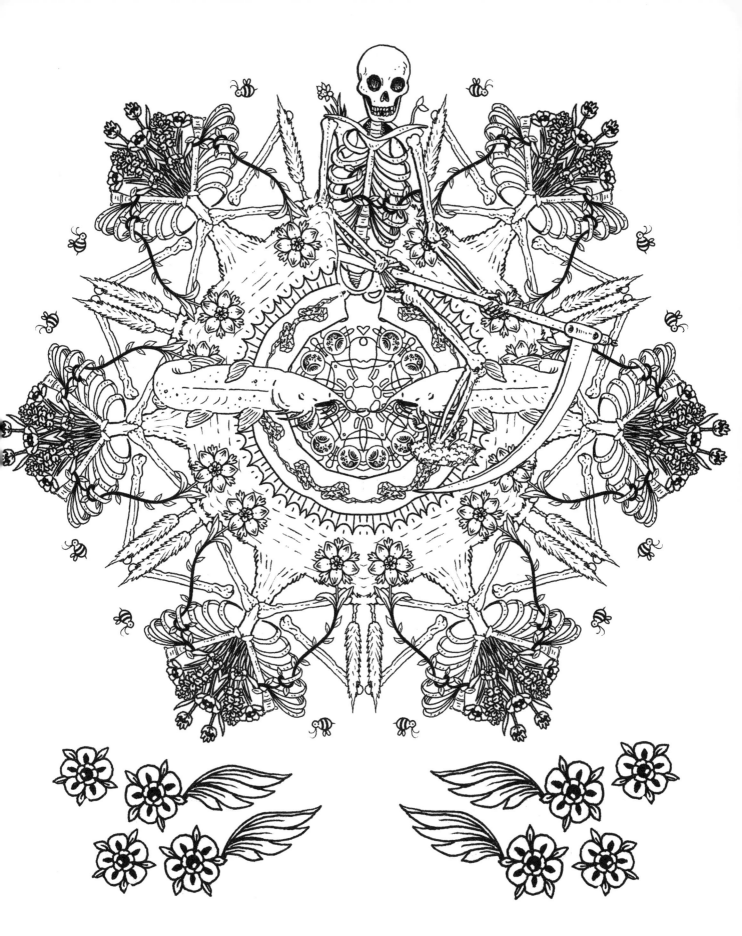

TEMPERANCE

PATH OF HEALING

Temperance is a noun, but it describes an attitude that translates to behavior: to be temperate is to base one's response on the situation at hand. Healing comes from suffering, which is a reaction to a situation; it is self-work, which requires us to look within and temper that reaction. What about this situation hurts you the most? Is this a reaction that you can change by altering yourself? Or is it the situation that must be altered? Temperance invites you to view all aspects equally, and ensure that if you encounter this situation again, you know how best to react to it.

SPIRITUALITY

The card Temperance has long been associated with alchemy, the precursor to much of modern science. Alchemy laid the groundwork for modern chemistry and even some aspects of medicine, but it was also a spiritual, magickal philosophy. Alchemists made it their lives' work to understand the natural world — and what lies beyond — through the combination of the four elements and the transformations that would occur. As such, Temperance is symbolic of this process. The angelic figure seeks to combine two elements — but only with a balance of mind and matter can the intended transformation be achieved.

ANIMALS

Here we see the snake whose skin rests at the feet of Death, thereby connecting the two cards. Temperance is all about balancing dualities and learning how to adjust to any situation you may encounter — and Death is the dark side to the greatest duality of all. The snake also represents knowledge in Abrahamic religions, and medicine, as a snake is entwined with the Rod of Asclepius — the Greek god of healing. The bee appears again, symbolic here of the communities, or hives, we can form when we have understood the relationship between our inner lives and the outer world — in other words, when we have learned to temper the needs of the self with the needs of others.

IN A NUTSHELL...

Balance is the key to a happy life, as it allows us to move through the world and temper our reactions to each situation. Learn to spot the dualities around you, and where they come into conflict. In what way can you right this imbalance? And when is it better just to walk away?

SYMBOL SECRETS

RAINBOW

The rainbow symbolises new beginnings and relates to Iris, the Greek goddess who rode the rainbow to deliver judgement to the gods. Rainbows are also the symbol of the LGBTQ+ community, with each color ascribed a specific meaning. Temperance also speaks to dualities in society: for queer people, this means being othered, and the community you can build outside the rule of norms.

PATH

The path leads out of the pool, into the distant mountains, where a golden glow awaits. This is the higher knowledge that can be obtained from the completion of the Major Arcana's great work... but we are not there yet. Look out for other distant glows in the tarot — on what other cards does this symbol appear, and how does it affect the card's meaning?

SYMBOLS

o o o o o o o o o

SUN
MOON
RAINBOW
WINGS
MOUNTAINS
CUPS
POOL
PATH
DISTANT GLOW
SNAKE

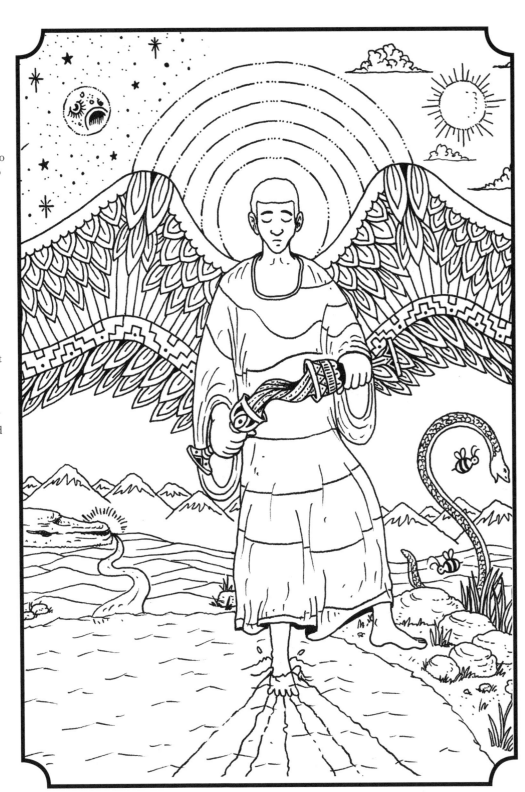

REFLECTIONS

Do you feel that your inner self is in conflict, or harmony, with the outer world?

..

..

..

..

What are you constantly balancing in your own life? How do you maintain this balance?

..

..

..

..

PRACTICE

For this meditation, you will need two cups. Fill the first with one liquid, and the second with a different liquid (e.g.: milk and water, vinegar and oil, etc). Ground yourself as you would normally. Then, focus on the cups. Really look at the liquids. Let them fill your vision and your mind, until everything else melts away.

Next, pour the liquid from the left cup into the right, and observe how the liquids combine. Then, pour the mixture from the right cup back into the left. Keep doing this, watching how the liquids swirl. Has the color changed? What happens if you leave them to rest, then mix them again? This is a focus meditation, so you can continue for as long as you like.

Record anything interesting about the experience here:

..

..

..

..

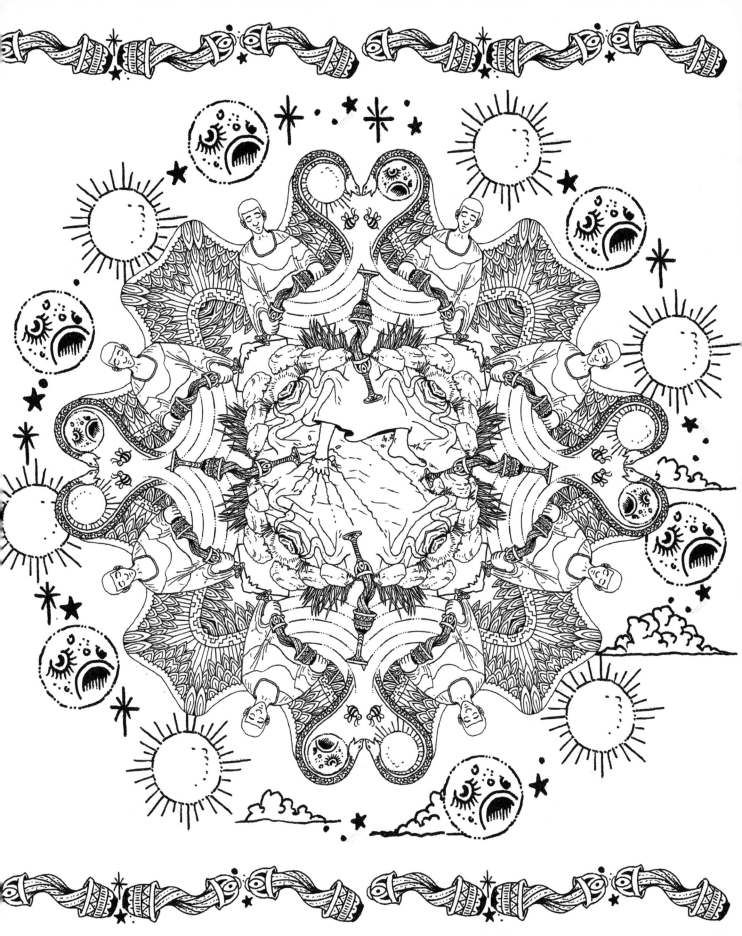

THE DEVIL · XV

PATH OF HEALING

What's your guilty pleasure? We all have our indulgences, and in moderation they can be self-care. It's easy for indulgence to swing into gluttony, however, and we can become trapped in a pattern of self-gratification. Take what you need from this space: here you can find what you need to carry on. Just be sure not to dawdle too long, for those who tarry court death...

SPIRITUALITY

Where did the Devil come from? Demons and evil spirits exist throughout folklore, along with gods who thrive on discord. And yet, those who rule the various mythological underworlds aren't necessarily evil — that idea was propagated by Christianity, who cast Satan in the image of pagan woodland deities. On this card, the Devil figure resembles the Greek god Pan and the British god Herne the Hunter, implying that we should question our preconceptions. But the Faustian pact is also clear: in the pursuit of our goals (note the tools of the Minor Arcana, the same ones that the Magician used), our hubris can sometimes go too far. The key is finding the balance and realizing when another is trapping us — or when we are trapping ourselves.

ANIMALS

A snail moves slowly across the forest floor. This is its home, and it is happiest here beneath the trees' dense canopy, traversing the dark, mulchy earth. The snail's is the best path out of this forest of temptation — stay grounded, focus on the destination, and take only what you need. And remember, you can always find shelter within yourself, just as the snail slumbers in its shell, safe from harm and distraction.

IN A NUTSHELL...

"If I possess any knowledge at all, I will walk on the great path of Tao, and my only fear will be straying from it." So Lao Tzu warned of what happens when we stray from the path and become bogged down in trivial concerns and petty grievances. Still, Dante had to cross the Inferno before reaching Paradise. As you indulge yourself, just keep your eye on that horizon — and beware of getting so immersed that you cannot see the wood for the trees.

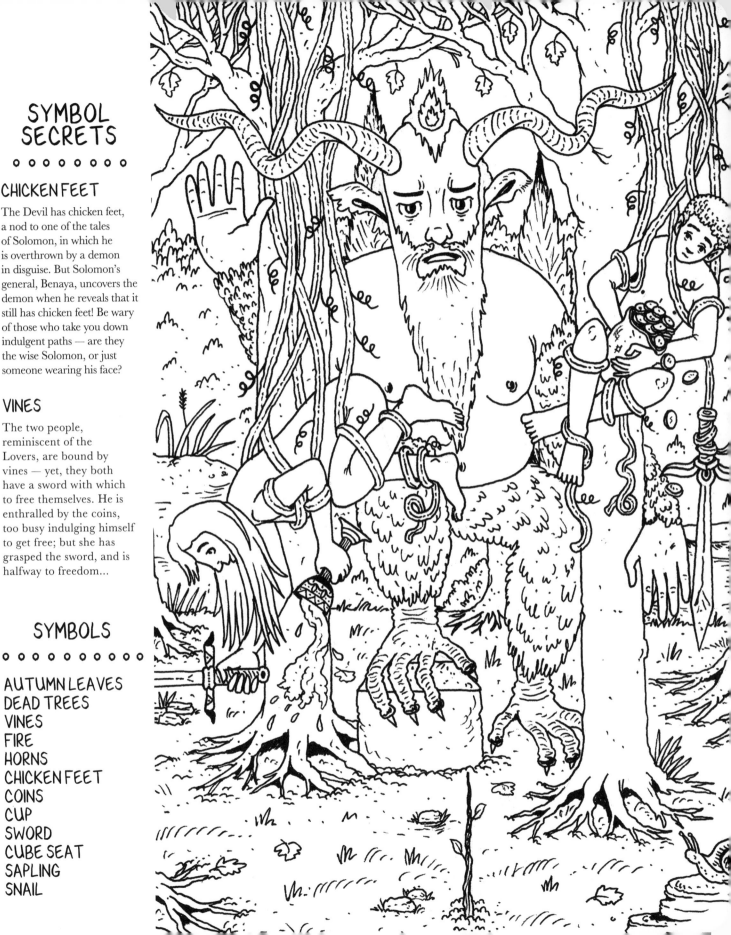

SYMBOL SECRETS

o o o o o o o o

CHICKEN FEET

The Devil has chicken feet,
a nod to one of the tales
of Solomon, in which he
is overthrown by a demon
in disguise. But Solomon's
general, Benaya, uncovers the
demon when he reveals that it
still has chicken feet! Be wary
of those who take you down
indulgent paths — are they
the wise Solomon, or just
someone wearing his face?

VINES

The two people,
reminiscent of the
Lovers, are bound by
vines — yet, they both
have a sword with which
to free themselves. He is
enthralled by the coins,
too busy indulging himself
to get free; but she has
grasped the sword, and is
halfway to freedom...

SYMBOLS

o o o o o o o o o

AUTUMN LEAVES
DEAD TREES
VINES
FIRE
HORNS
CHICKEN FEET
COINS
CUP
SWORD
CUBE SEAT
SAPLING
SNAIL

REFLECTIONS

What's your guilty pleasure?

...

...

...

...

...

Was there a time in your life when you overindulged?
What did you learn from this experience?

...

...

...

...

PRACTICE

Set aside some time to indulge yourself, and fill it with all the things you don't usually allow yourself. This is not the test; the test is to make sure that you don't *overindulge*. Find the balance. How much is too much? What do you need in order to support yourself, and what happens when you go too far?

...

...

...

...

...

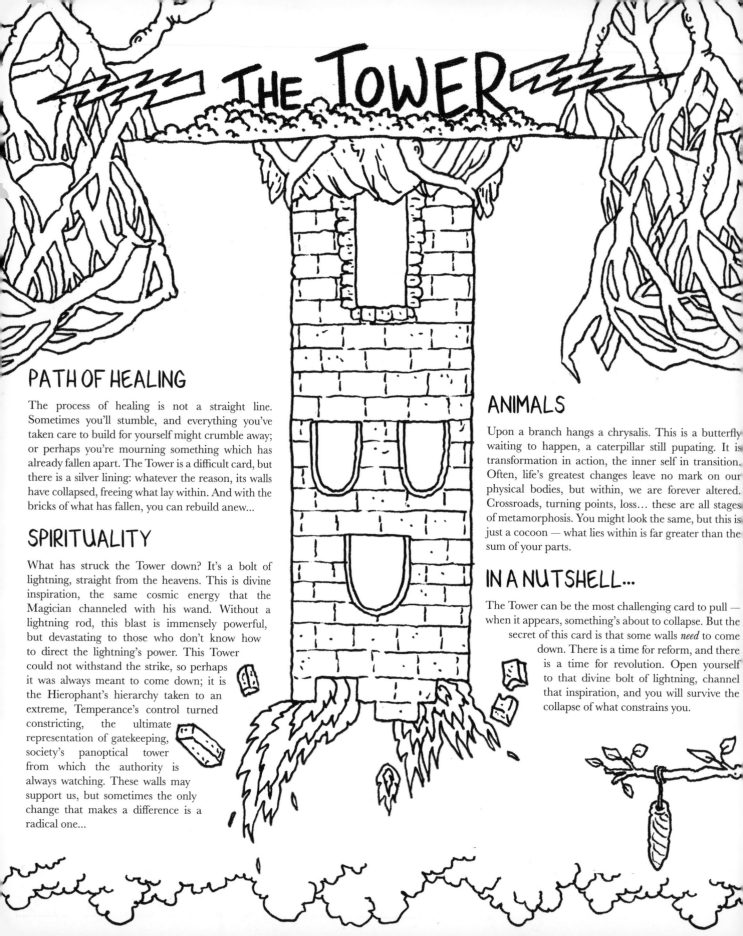

THE TOWER

PATH OF HEALING

The process of healing is not a straight line. Sometimes you'll stumble, and everything you've taken care to build for yourself might crumble away; or perhaps you're mourning something which has already fallen apart. The Tower is a difficult card, but there is a silver lining: whatever the reason, its walls have collapsed, freeing what lay within. And with the bricks of what has fallen, you can rebuild anew...

SPIRITUALITY

What has struck the Tower down? It's a bolt of lightning, straight from the heavens. This is divine inspiration, the same cosmic energy that the Magician channeled with his wand. Without a lightning rod, this blast is immensely powerful, but devastating to those who don't know how to direct the lightning's power. This Tower could not withstand the strike, so perhaps it was always meant to come down; it is the Hierophant's hierarchy taken to an extreme, Temperance's control turned constricting, the ultimate representation of gatekeeping, society's panoptical tower from which the authority is always watching. These walls may support us, but sometimes the only change that makes a difference is a radical one...

ANIMALS

Upon a branch hangs a chrysalis. This is a butterfly waiting to happen, a caterpillar still pupating. It is transformation in action, the inner self in transition. Often, life's greatest changes leave no mark on our physical bodies, but within, we are forever altered. Crossroads, turning points, loss... these are all stages of metamorphosis. You might look the same, but this is just a cocoon — what lies within is far greater than the sum of your parts.

IN A NUTSHELL...

The Tower can be the most challenging card to pull — when it appears, something's about to collapse. But the secret of this card is that some walls *need* to come down. There is a time for reform, and there is a time for revolution. Open yourself to that divine bolt of lightning, channel that inspiration, and you will survive the collapse of what constrains you.

SYMBOL SECRETS

EYE IN THE SUN

The eye within the sun belongs to Shiva; it is his third eye, which, when opened, burns anything it gazes upon. The third eye is higher consciousness, seeing the truth of the world with no filter or pretense. This kind of observation is terrifying — imagine if someone could see right to the heart of you! And that is precisely why it is destructive: because most cannot withstand the honesty exposed by this gaze...

RESPONSES

Two people plunge from the Tower. One is struck by a brick, about to perish in fire; the other is unperturbed, still in meditation, ready to sink beneath the cool waves. Just as one figure in The Lovers looked skyward for inspiration, and one of the Devil's captives actively freed herself, here again we can see how a single situation can be responded to in different ways — and how every situation is a potential opportunity.

SYMBOLS

EYE IN THE SUN
LIGHTNING BOLT
CROWN
FIRE
TOWER
ROOTS
BRICKS
WATER
CHRYSALIS

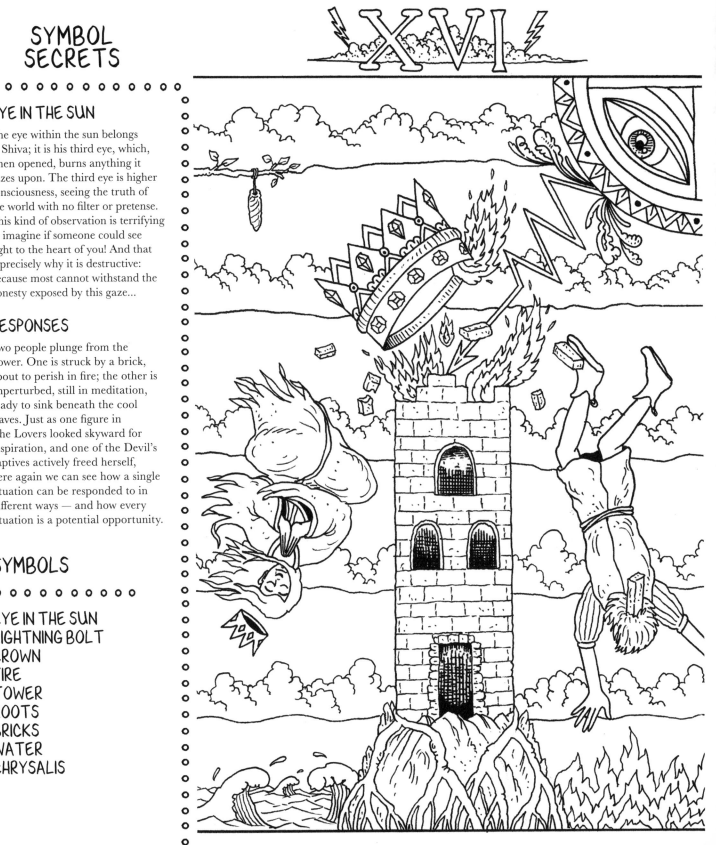

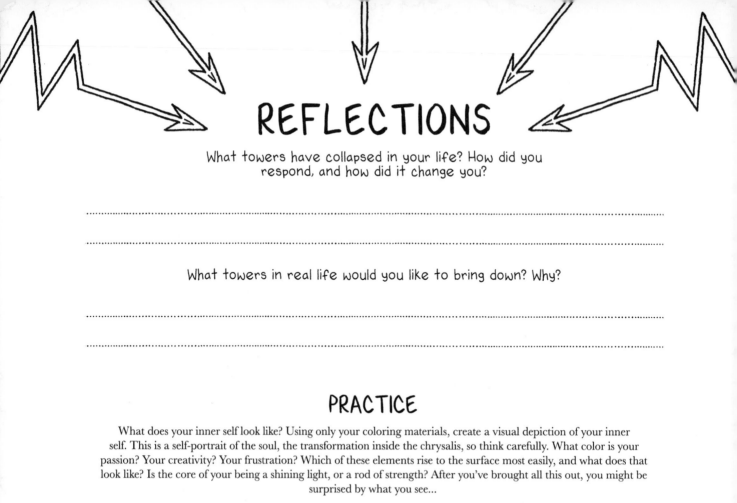

REFLECTIONS

What towers have collapsed in your life? How did you respond, and how did it change you?

...

...

What towers in real life would you like to bring down? Why?

...

...

PRACTICE

What does your inner self look like? Using only your coloring materials, create a visual depiction of your inner self. This is a self-portrait of the soul, the transformation inside the chrysalis, so think carefully. What color is your passion? Your creativity? Your frustration? Which of these elements rise to the surface most easily, and what does that look like? Is the core of your being a shining light, or a rod of strength? After you've brought all this out, you might be surprised by what you see...

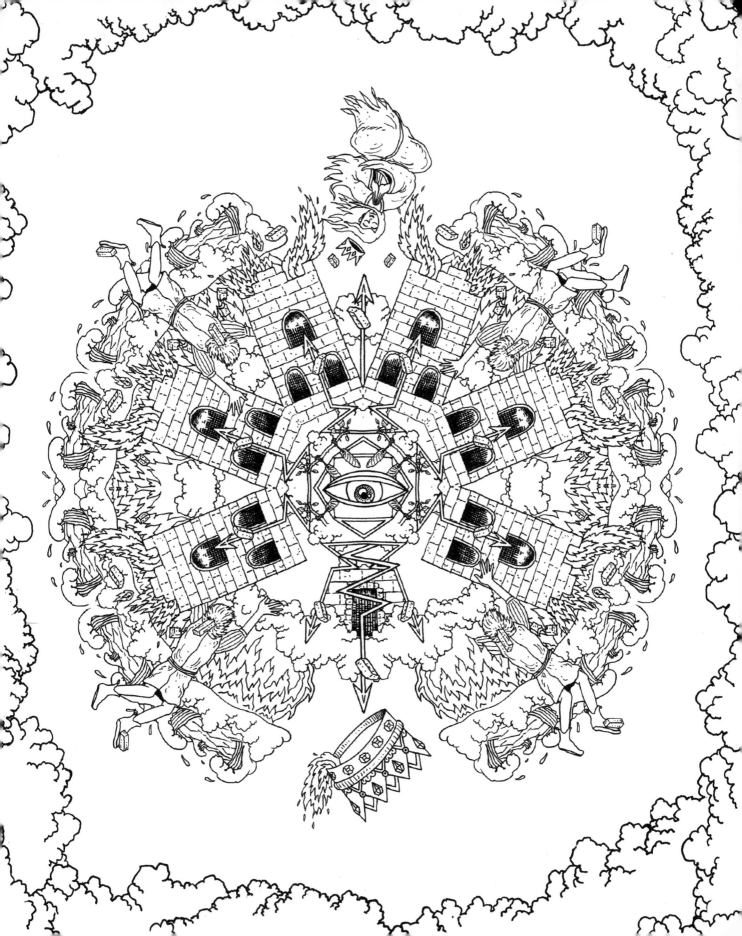

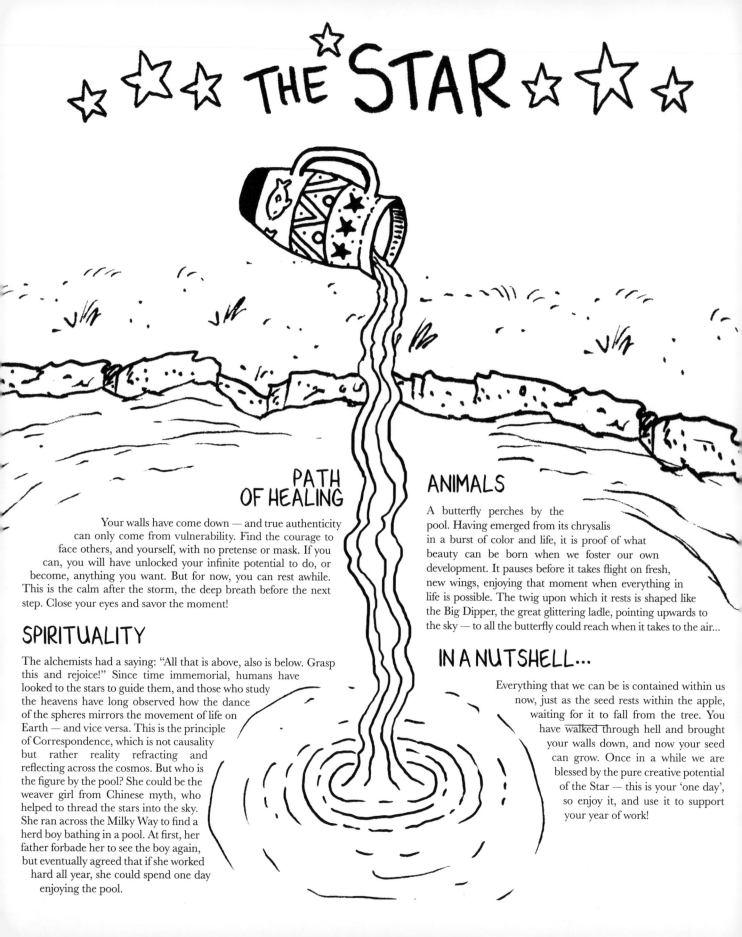

☆ ☆ ☆ THE STAR ☆ ☆ ☆

PATH OF HEALING

Your walls have come down — and true authenticity can only come from vulnerability. Find the courage to face others, and yourself, with no pretense or mask. If you can, you will have unlocked your infinite potential to do, or become, anything you want. But for now, you can rest awhile. This is the calm after the storm, the deep breath before the next step. Close your eyes and savor the moment!

SPIRITUALITY

The alchemists had a saying: "All that is above, also is below. Grasp this and rejoice!" Since time immemorial, humans have looked to the stars to guide them, and those who study the heavens have long observed how the dance of the spheres mirrors the movement of life on Earth — and vice versa. This is the principle of Correspondence, which is not causality but rather reality refracting and reflecting across the cosmos. But who is the figure by the pool? She could be the weaver girl from Chinese myth, who helped to thread the stars into the sky. She ran across the Milky Way to find a herd boy bathing in a pool. At first, her father forbade her to see the boy again, but eventually agreed that if she worked hard all year, she could spend one day enjoying the pool.

ANIMALS

A butterfly perches by the pool. Having emerged from its chrysalis in a burst of color and life, it is proof of what beauty can be born when we foster our own development. It pauses before it takes flight on fresh, new wings, enjoying that moment when everything in life is possible. The twig upon which it rests is shaped like the Big Dipper, the great glittering ladle, pointing upwards to the sky — to all the butterfly could reach when it takes to the air...

IN A NUTSHELL...

Everything that we can be is contained within us now, just as the seed rests within the apple, waiting for it to fall from the tree. You have walked through hell and brought your walls down, and now your seed can grow. Once in a while we are blessed by the pure creative potential of the Star — this is your 'one day', so enjoy it, and use it to support your year of work!

POOL

While Temperance poured water from one cup to another, combining elements to create new ones, here the girl pours the water into the pool and onto the shore. Thus, it returns to the pool of divine unconscious whilst also feeding the earth, aiding the growth of roots from which new life can spring.

SEVEN STARS

In Chinese mythology, these seven stars — the Pleiades — keep court for the Emperor, who in turn maintains a watchful eye on his daughter: the girl by the pool. Ever vigilant in his love, the Emperor ensures the girl stays safe even as she enjoys her day of rest.

SYMBOLS

○ ○ ○ ○ ○ ○ ○ ○ ○

STARS
BIG STAR
MOUNTAIN
JUGS
POOL
TWIG
BUTTERFLY

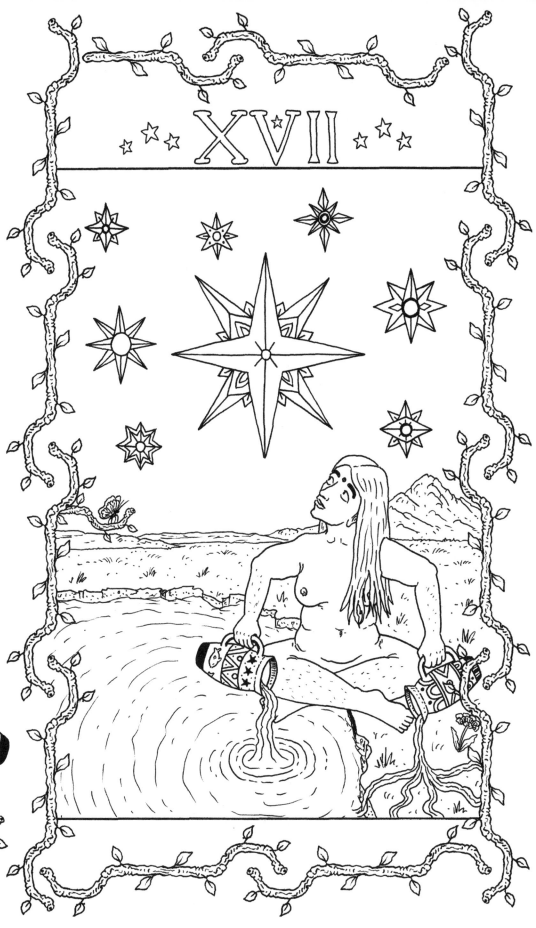

REFLECTIONS

When in your life did you feel most creative?

...

...

...

...

What holds you back from pursuing what you most want to create?

...

...

...

...

PRACTICE

Now's your moment to tap into that creative potential, so seize it! Use this space to note down any ideas you've been waiting to develop. Is there a project you've always wanted to work on? Or perhaps there's something you just love to imagine, but you're distracted by work and responsibilities — what is that daydream?

...

...

...

...

...

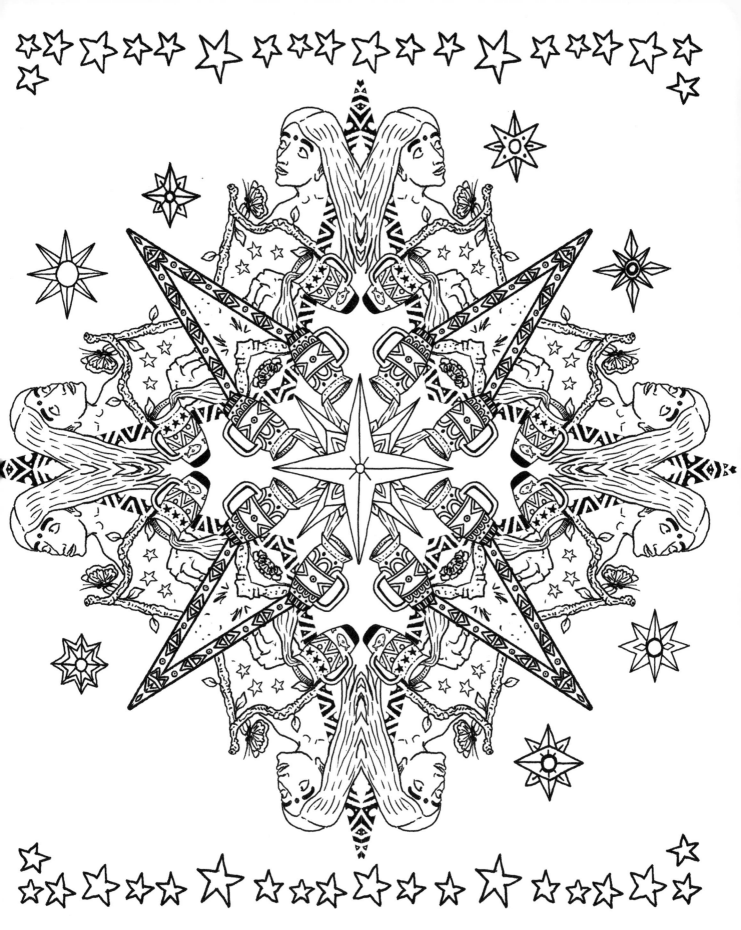

THE MOON

PATH OF HEALING

The Moon is the realm of dreaming and illusion. We have to let loose once in a while, free our wild side and run naked in the moonlight. (Metaphorically. Probably.) But shapes change in the light of the moon and things are not always as they appear. So, unleash yourself and run free, but keep your wits about you!

SPIRITUALITY

The Moon card is symbolic of the mythic Underworld — not a hellish inferno, but the realm which lies beyond the veil separating life and death, day and night. The descent into the Underworld is a staple journey in mythology that transcends cultural divides, and it is often related to the change in seasons, as in the case of the Greek goddess Persephone and the Sumerian goddess Inanna. This descent often causes the protagonist to confront their darkest self: by challenging her sister Ereshkigal for the throne of the Underworld, Inanna lost first her life and later her husband, who in his own hubris had claimed Inanna's throne for himself. But there must also be someone to lead you out of the Underworld. Hecate, goddess of magic and the moon, guided Persephone to the surface, lighting the way with her twin torches — which also appear on this card.

ANIMALS

Populating this moonlit otherworld are several creatures. The wolf and the dog share a point of origin: they are each other's 'road not taken', and so they represent the diverging paths within you. Will you run like the wolf, howling into the night? Or will you shape, and allow yourself to be shaped by others, just as the ancient dogs shared their lives with humans? Lurking at the base of the card, emerging from the pool, is a lobster. The lobster represents the most primitive self — but notice the color. Lobsters only turn red when they boil… the pool has transformed into a hot spring under the cool moonlight, adding to the eeriness of the scene.

IN A NUTSHELL…

This is the strangeness that dwells within all of us and only emerges at night, in the slumbering world. Jung believed that our dreams connect us to the collective unconscious, where all archetypes dwell. There is a mythic quality within all of us, and the Moon urges you to find a way to acknowledge that part of yourself — as long as you don't lose your way!

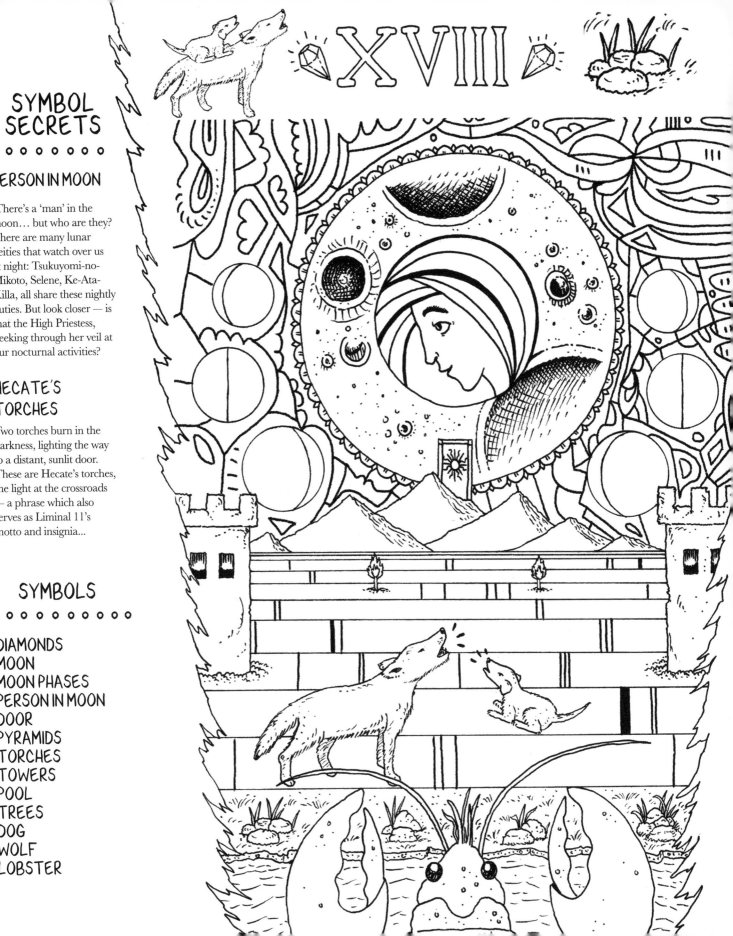

SYMBOL SECRETS

PERSON IN MOON

There's a 'man' in the moon… but who are they? There are many lunar deities that watch over us at night: Tsukuyomi-no-Mikoto, Selene, Ke-Ata-Killa, all share these nightly duties. But look closer — is that the High Priestess, peeking through her veil at our nocturnal activities?

HECATE'S TORCHES

Two torches burn in the darkness, lighting the way to a distant, sunlit door. These are Hecate's torches, the light at the crossroads — a phrase which also serves as Liminal 11's motto and insignia…

SYMBOLS

DIAMONDS
MOON
MOON PHASES
PERSON IN MOON
DOOR
PYRAMIDS
TORCHES
TOWERS
POOL
TREES
DOG
WOLF
LOBSTER

REFLECTIONS

What's the wildest thing you've ever done?

..
..
..
..

Do you think you're in touch with your dark side? What's your relationship with it?

..
..
..
..

PRACTICE

Keep a notebook by your bed for a week. Every morning when you wake up, record three things you remember most clearly from your dreams, and three thoughts you had upon waking. At the end of the week, read back over this journal and see if you can find any patterns or meanings. Write your conclusions here:

..
..
..
..

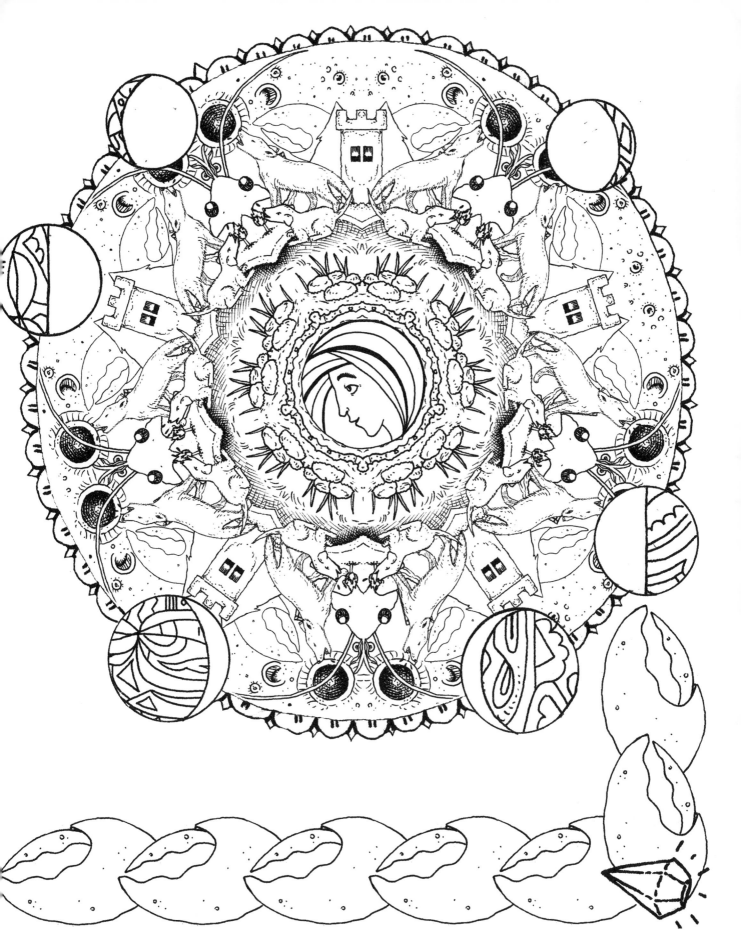

THE SUN

PATH OF HEALING

You've been to hell and back, have confronted your deepest self, and brought your walls tumbling down. Now, it's time to have some fun. What brought you joy as a child? What makes you shout with laughter, or want to leap into a dance? This is still within your reach, so recapture it. Don't be ashamed of this joy: it is the ultimate antidote to suffering.

ANIMALS

The unicorn has long represented innocence and purity — it is the ultimate form of uncorrupted life and the joy of the natural world. In modern culture, the unicorn has also become synonymous with the LGBTQ+ community as a symbol of pride in otherness and difference from the norms imposed by society. Butterflies, too, symbolize joy; but the Monarch Butterfly has special significance in Mexican folklore. Migrating to Mexico in autumn, the Monarchs arrive around Día de los Muertos, the Day of the Dead, and are said to be the souls of the deceased finding their way home for the annual celebration of their previous lives.

SPIRITUALITY

The sun is perhaps the most popular object of worship. Early cultures often worshipped the sun in and of itself first, before developing this concept into personification: the sun as a god, like Helios, Ra, and Amaterasu. Psychological studies have shown that sunlight is a huge contributor to mental wellbeing, as it stimulates the production of serotonin, dopamine, and melatonin. Put simply, the sun is joy incarnate — and joy is the cornerstone of this card. But what does it mean to be joyful? The Buddha taught the importance of *mudita*: "unselfish joy, abundant, measureless, without hostility or ill-will." It's the feeling you get when a sunbeam hits your face, or when you hear a child laugh. It's life, filled with the glee of its own existence.

IN A NUTSHELL...

"Almost all capable people are terrified of being ridiculous and are miserable because of it." So said Fyodor Dostoevsky, and unfortunately, he's right. As children, we experience such easy, swift joy at the simplest of things. As adults, this slips away from us as we become wrapped up in responsibility and the fallacy of maturity. The more aware we become of ourselves, the more self-conscious we grow. Perhaps we're just too embarrassed to embody that childish glee; but true maturity comes from learning to put all these adult pretenses aside. Life is tough, yet being alive is the greatest gift of all. So enjoy it!

SYMBOL SECRETS

o o o o o o o o

FLOWERS

In the Sun's garden grow the seeds that were planted in other cards — literally. The Magician tends roses, irises grow by Temperance's pool, a daffodil decorates the Two of Swords. The tarot is accumulative, and only by experiencing everything you have so far can you learn to embrace the joy of the Sun.

FAIRY RING

Fairy rings are prevalent in folklore, particularly in the British Isles. They can be found in meadows and woodland, marked by rocks, toadstools, or just a faded circle of grass. Upon stepping into this ring, you will be transported to the magical land of the fae… perhaps even to be wed to the fairy monarch!

SYMBOLS

o o o o o o o o o

SUN
IRIS
DAFFODIL
SUNFLOWER
ROSE
WALL
DHARMA
FLOWER
RING
UNICORN
BUTTERFLY

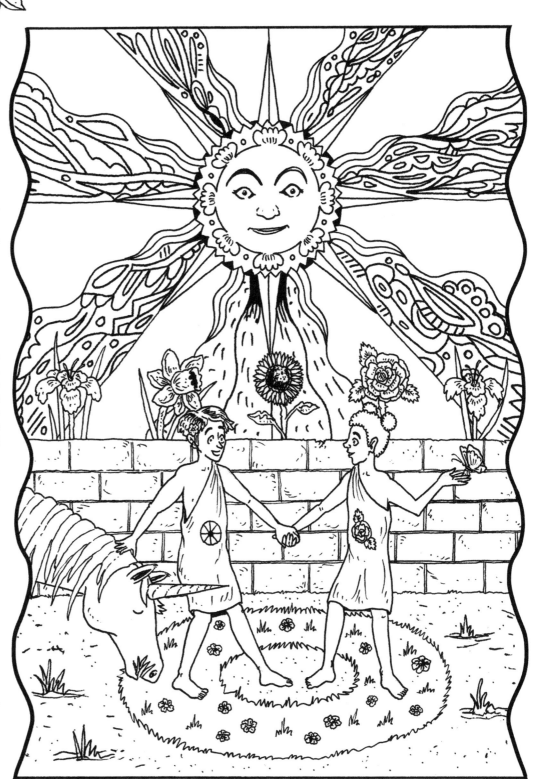

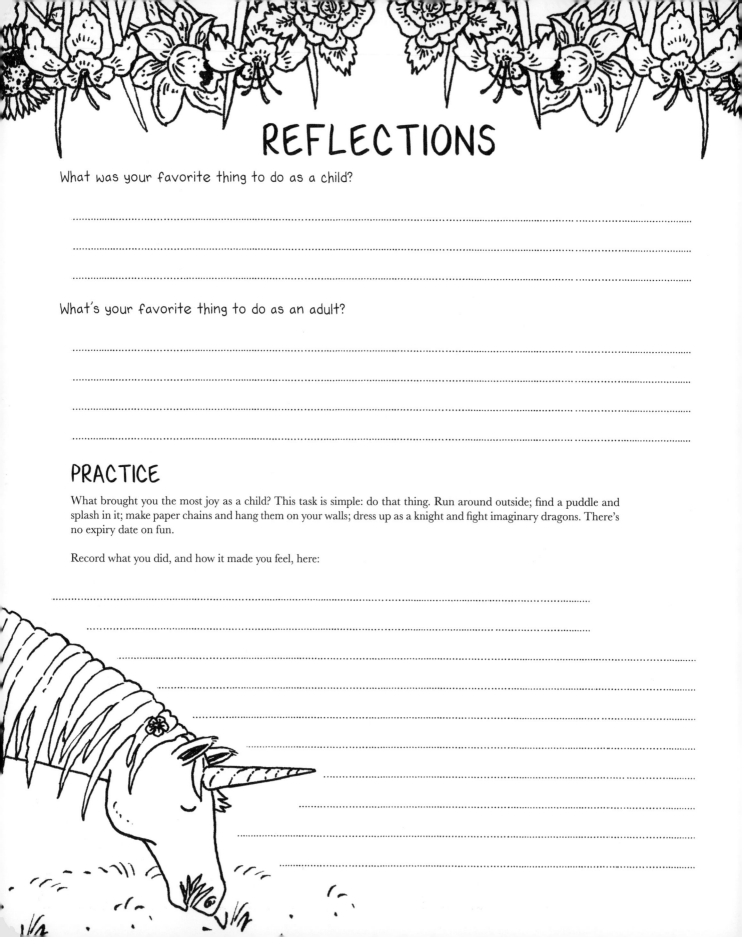

REFLECTIONS

What was your favorite thing to do as a child?

...

...

...

What's your favorite thing to do as an adult?

...

...

...

...

PRACTICE

What brought you the most joy as a child? This task is simple: do that thing. Run around outside; find a puddle and splash in it; make paper chains and hang them on your walls; dress up as a knight and fight imaginary dragons. There's no expiry date on fun.

Record what you did, and how it made you feel, here:

...

...

...

...

...

...

...

...

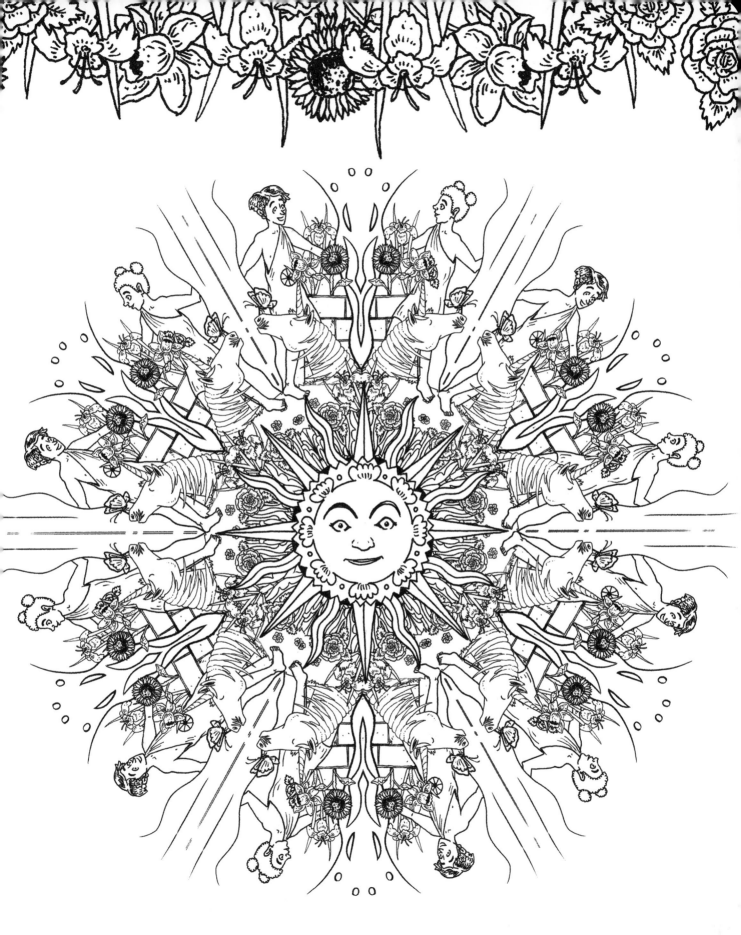

JUDGEMENT

PATH OF HEALING

Rest and recuperation are essential to healing, but as we've seen on this journey, it's also important to reach out to others, examine your responses to situations, and re-learn how to experience joy. As you're coming to the end of your journey, you may be wondering what comes next. When Judgement appears, your vocation is just around the corner, so pay attention: anything can be an opportunity in disguise...

SPIRITUALITY

The Day of Judgement is an event that appears in several mythologies, predominantly in Abrahamic religions — and it has an ominous tone to it. It is the end of the world, humanity's civilisation in twilight, when we will all stand to be judged; only then can we proceed to the afterlife. There have been more optimistic spins on this apocalyptic event, however: Crowley's version of the card is entitled *The Aeon*, and it deals with the construction of utopia after the end of days. For every ending is a new beginning, and Judgement Day resurrects souls long dead. Perhaps, then, it falls upon us to create heaven for ourselves.

ANIMALS

Justice's cat appears again here, tying these two cards together. Just as Justice urged you to consider your past and present self as future-building, Judgement calls upon you to take that step into the future. This cat reminds you of who you were — your past is the coffin in which the cat sits, turning it into a boat. Your past upholds you, and you can use it to sail to your next horizon.

IN A NUTSHELL...

We have no idea what's waiting for us after death, but we know what we have here on Earth. Judgement is the call to action, to build the kind of world that will benefit all of us. The Persian poet Rumi said: "Let yourself be silently drawn by the strange pull of what you really love." There is no fate except that which we make for ourselves — so make it a good one!

SYMBOL SECRETS

★ ★ ★ ★ ★ ★ ★ ★ ★ ★ ★ ★ ★ ★ ★ ★ ★

FOREHEAD SYMBOL

At the center of this celestial figure's forehead is a symbol: a representation of the hydrogen atom, a nod to Alan Moore's graphic novel *Watchmen* (Dr. Manhattan has the same symbol on his forehead). This simple atom contains just one proton and one electron, and yet it makes up 75% of the universe.

EYE DIRECTION

Notice the figure's other eyes: they are directed down, up, and inwards. None are facing forwards. This is a being that has achieved enlightenment, moving naturally forwards without effort, with constant awareness of the other planes of existence — what lies below and above — and its own inner self.

SYMBOLS

o o o o o o o o o

MOON
TORCH
FOREHEAD SYMBOL
MULTIPLE EYES
TORCH
MULTIPLE ARMS
MAYAN NUMERAL 11
FLUTE
SUN
RAINBOW
SEA
COFFIN
CAT

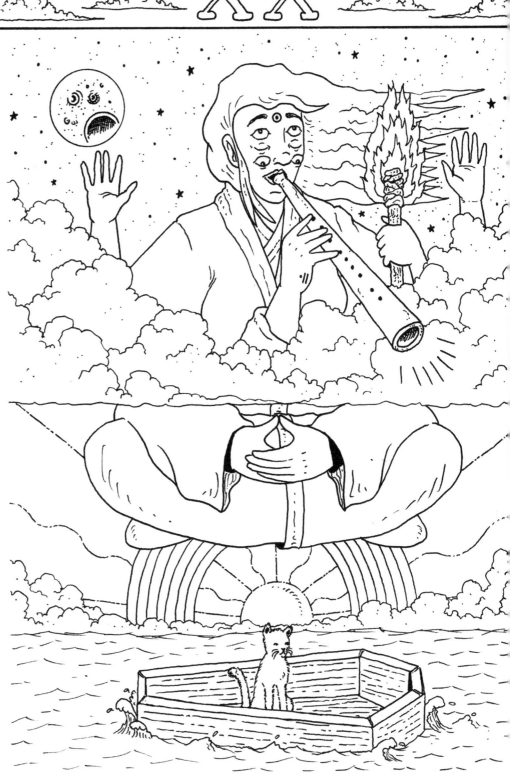

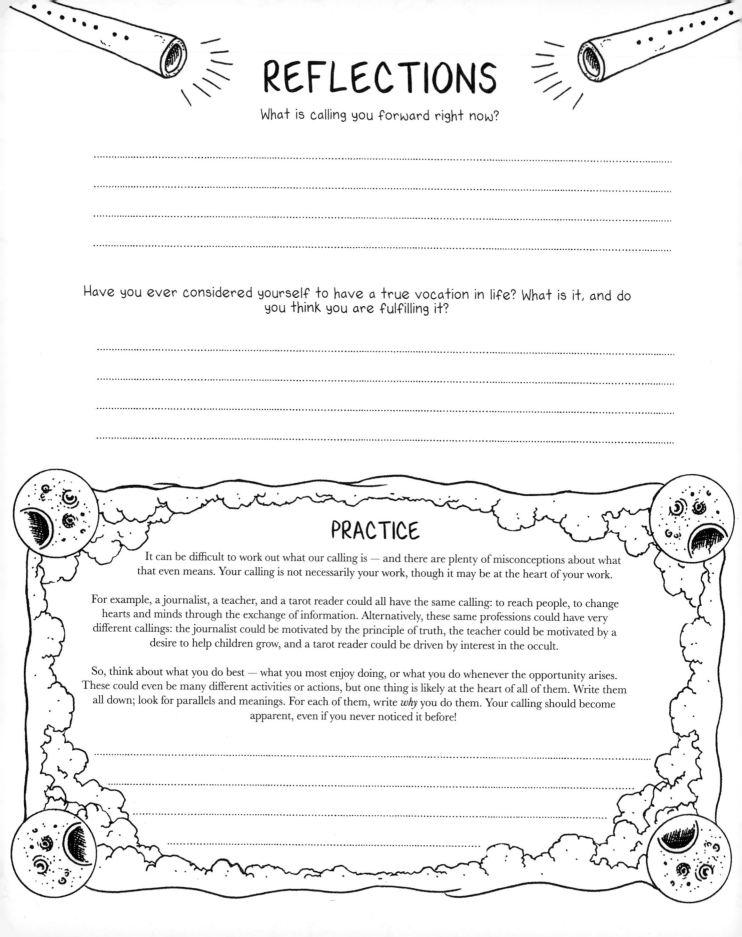

REFLECTIONS

What is calling you forward right now?

..

..

..

..

Have you ever considered yourself to have a true vocation in life? What is it, and do you think you are fulfilling it?

..

..

..

..

PRACTICE

It can be difficult to work out what our calling is — and there are plenty of misconceptions about what that even means. Your calling is not necessarily your work, though it may be at the heart of your work.

For example, a journalist, a teacher, and a tarot reader could all have the same calling: to reach people, to change hearts and minds through the exchange of information. Alternatively, these same professions could have very different callings: the journalist could be motivated by the principle of truth, the teacher could be motivated by a desire to help children grow, and a tarot reader could be driven by interest in the occult.

So, think about what you do best — what you most enjoy doing, or what you do whenever the opportunity arises. These could even be many different activities or actions, but one thing is likely at the heart of all of them. Write them all down; look for parallels and meanings. For each of them, write *why* you do them. Your calling should become apparent, even if you never noticed it before!

..

..

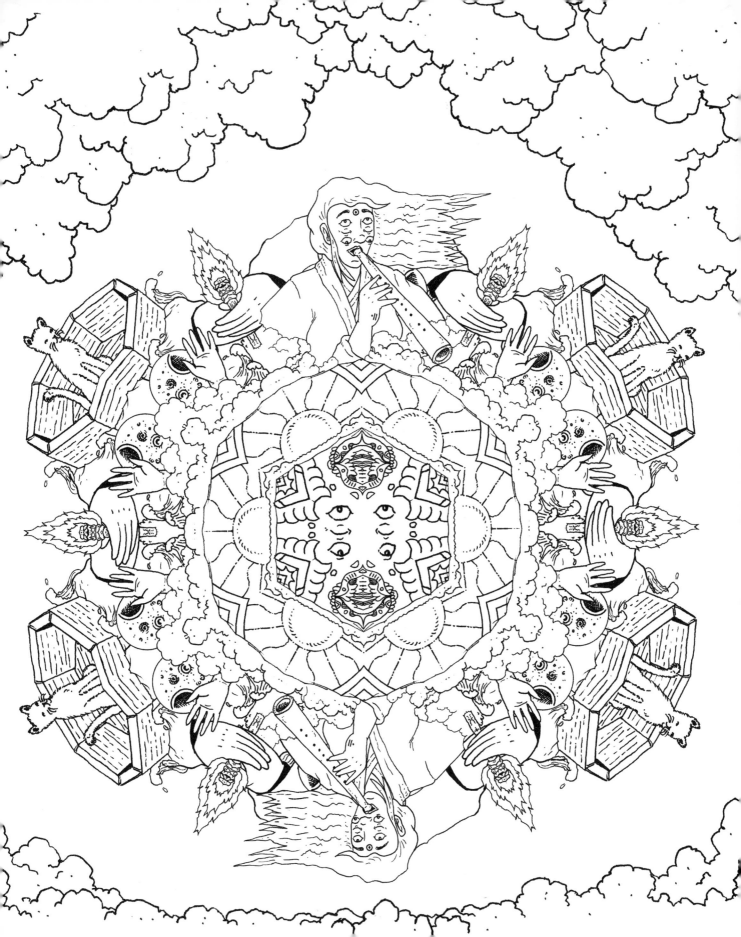

THE WORLD

PATH OF HEALING

You've arrived. This is the moment of true recovery — and as such, it will probably pass unnoticed. You are no longer borne back ceaselessly into the past; now, you move forward with the current. Usually, we don't realize we've recovered until long after the moment of recovery. We notice that we're living a little lighter, thinking of what occupies us rather than what has hurt us. But for all that this moment passes without notice, it's worth celebrating. You made it. I'm proud of you.

SPIRITUALITY

We've talked about Tao a lot in this book, but what is it? Tao is the source of all life in the universe, the force of life itself. Everything comes from nothing, the primordial chaos that formed the blueprint for all that is. This isn't necessarily a creation myth — it's more metaphysical than that. All of us come from this nothingness, embodied by the Fool, and life is a process of returning to Tao — and this process is known as *tzu ran*. As Solala Towler posits in *Practicing the Tao Te Ching*, the principle of tzu ran is that existence begets itself: the act of living is creates reality. The World card is the epitome of this idea: life as a fully realized creation, existing spontaneously without premeditation or impediment. The entirety of the Major Arcana is a journey towards this moment, a slow understanding of what it means to be alive. The World is the journey concluded and yet never complete — because life continues onwards, always, towards eternity.

ANIMALS

As in the Wheel of Fortune, the animals (and human entity) on this card represent the fixed signs of the Zodiac, and the four corners of the Earth. They are a visual and symbolic shorthand for everything — the everything that the World encapsulates.

IN A NUTSHELL...

The hardest thing in this world is to live in it. We can exist, oblivious and letting life slip by, bogged down by responsibility and stress. But *truly* living, embodying that perfect forward motion of life in perpetuation… that's very difficult to achieve. That's what Zen and Buddhist monks are all chasing: it's enlightenment. But maybe you don't need to study doctrine and philosophy for years; maybe you just need to appreciate life for what it is and recognize that you are part of it. You're not just living life, you *are* life. And that's the most beautiful, chaotic, flawed, wonderful thing in the universe.

SYMBOL SECRETS

HEART

A heart beats at the center of the dancer. This is pure love, the kind that thrums through the universe, connecting all of us and making life worth living. Everything comes back to love in the end, because without it we would have nothing.

POSE

The dancer's pose should be familiar — it's the mirror image of the Fool's walking pose! The Fool and the World are intrinsically connected. If the Fool is nothing, the World is everything — but each principle is contained within the other. Everything the Fool can become is contained within the World, and everything the World is comes from the Fool...

SYMBOLS

○ ○ ○ ○ ○ ○ ○ ○ ○

HUMAN
EAGLE
OX
LION
DIAMOND
INFINITY SYMBOL
LAUREL WREATH
SUN
MOON
HEART
RIBBON
POSE

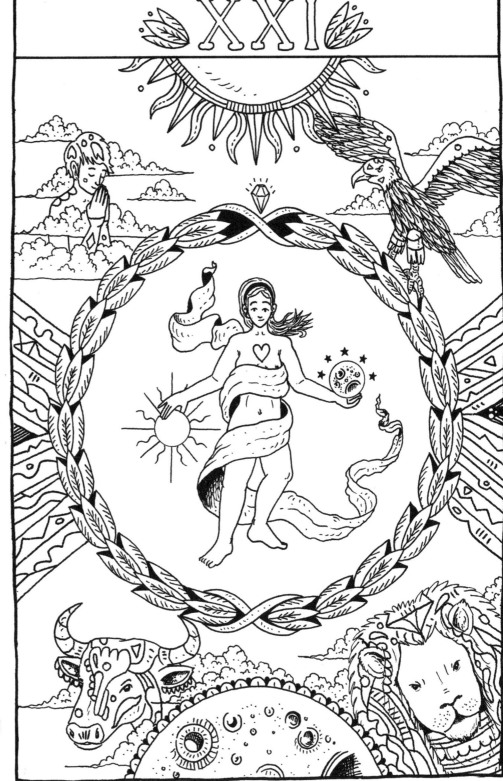

REFLECTIONS

What's your favorite thing about being alive?

..

..

Have you ever thought much about the universe? How does thinking about the universe make you feel about yourself?

..

..

..

PRACTICE

Using whatever materials you like, draw yourself and the universe. This could mean a stick figure floating in the cosmos, a figure holding a fairy cake (all of life is contained within everything else, however small), or an abstract expression of light, darkness and color. Really think about the universe, and your place within it. It's all in you, so go wild!

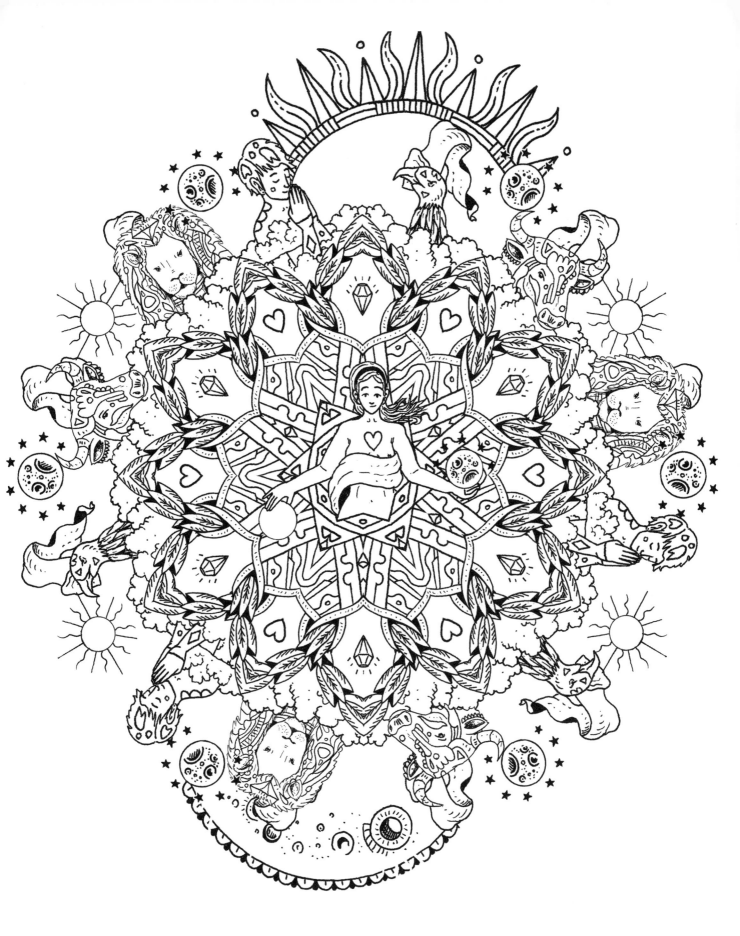

DUALITY

PATH OF HEALING

Duality is essential to reality. Everything has its opposite — and entire universes exist in the nuances between these two opposing poles. There are many dualities within you, as well. By getting too attached to any one idea we risk becoming defined by it. But between the two poles of duality lies a path. Healing is understanding that we don't have to be one thing or another: sometimes we can be both.

SPIRITUALITY

Everything in the universe can only be defined as it relates to something else. As Lao Tzu said: "Long and short illustrate each other; high and low rest upon one another." The light casts shadow, so we know it is day. The sun sets, so we know it is night. We speak to others, so we know the self does not exist alone. One person's justice is another's cruelty. But just as everything can only be understood in relation to something else, everything also depends on everything else in order to exist.

REFLECTION

What dualities do you embody?

..

..

..

..

PRACTICE

What are we to each other? The answer is 'everything', if you go by the Taoist princip of duality. So, don't cut yourself off — you are only you in relation to others, and vid versa. Write down which parts of yourself you have learned from those in your life, goo and bad. Then, write down which aspects of yourself you recognize in those around you — perhaps they learned these attributes from you!

..

..

..

..

WU WEI

PATH OF HEALING

Don't overdo it. That's the lesson at the heart of the Taoist practice of Wu Wei — it's all about learning your limits. Overextending yourself is not only unnecessary, but harmful. You may be inclined to go the extra mile, especially if you've been hurt before. That hurt can knock you down, make you feel worthless — and so you want to overcompensate to prove your worth. But you don't have to prove anything to anyone, much less yourself. Just do what you can, and that will always be enough.

SPIRITUALITY

Wu Wei is a Taoist practice, and perhaps the most important one. It means, put simply, to take the path of least resistance, to cultivate effortless action — to do by not doing. It is not passivity or apathy, however. Even the smallest stream will cut a deep groove in the rock, given enough time. The calligrapher paints a character with just one, perfect brushstroke — and yet it has taken them years, if not decades, of work and patience to master that seemingly effortless flick of the wrist. It can take a lifetime to learn how to do just enough. Good thing you have a lifetime to learn it, then!

REFLECTION

What is something that you have been working on for years to do almost effortlessly?

..

..

..

..

PRACTICE

Dance has to look effortless in order for it to be beautiful, but it can take a lot of work to master even the simplest move. So, pick a dance move to learn over time. This could be a TikTok routine, a ballet pose, a tap rhythm… anything!

If your mobility is restricted, choose a simple melody to perfect. If vocalizing isn't possible, maybe it's time to learn some simple calligraphy. Whatever best fits you and your abilities, choose something that appears simple to master over time. It doesn't matter how long it takes you: what matters is the focus and work you put in so that you can do it with the least amount of effort. And who knows — maybe you will find a new hobby!

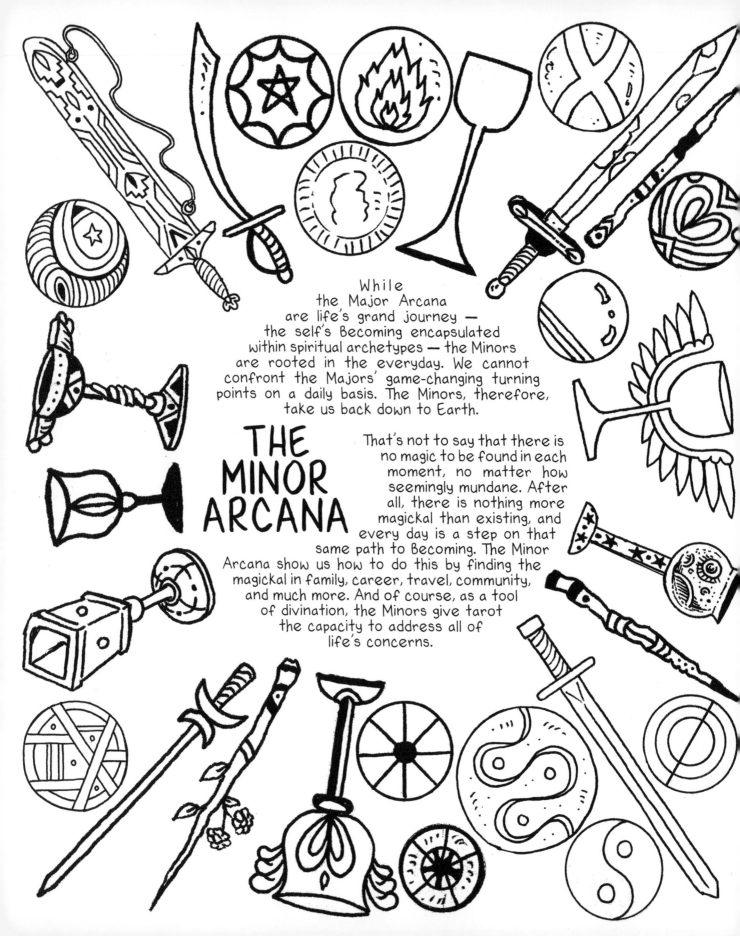

While
the Major Arcana
are life's grand journey —
the self's Becoming encapsulated
within spiritual archetypes — the Minors
are rooted in the everyday. We cannot
confront the Majors' game-changing turning
points on a daily basis. The Minors, therefore,
take us back down to Earth.

THE MINOR ARCANA

That's not to say that there is
no magic to be found in each
moment, no matter how
seemingly mundane. After
all, there is nothing more
magickal than existing, and
every day is a step on that
same path to Becoming. The Minor
Arcana show us how to do this by finding the
magickal in family, career, travel, community,
and much more. And of course, as a tool
of divination, the Minors give tarot
the capacity to address all of
life's concerns.

NUMBERS

Although the way they manifest differs from suit to suit, there are common themes across the numbers of the Minor Arcana...

ACE	seeds and new beginnings
TWO	harmony and balance
THREE	having and losing
FOUR	rest and reflection
FIVE	insecurity and conflict
SIX	stability and reward
SEVEN	inner strength and endurance
EIGHT	momentum and hope
NINE	reaping and recovery
TEN	responsibility and community

To help you familiarize yourself with the Minors, you could color in the cards in number groups, rather than methodically moving through each suit one by one, i.e.: try coloring all the Twos. What parallels can you find?

As you color them in, really contemplate each card. How does the Two of Cups differ from the Two of Disks? And how is this represented in each card's imagery? Do you recognize any moments from your own life?

You can record any thoughts you have about the Minor number cards here:

..

..

..

..

..

..

..

..

..

..

COURT CARDS

The main cast of the Minor Arcana, these cards are usually used to represent people in your life. Although they differ from suit to suit, just like the numbers, each character has certain themes attached to them...

PAGES	youth, naivety, innocence. Someone just starting out in the world.
KNIGHTS	vitality, action, charisma. Knights know what they want and they're out to get it.
QUEENS	community, compassion, care. Natural nurturers with a core of power.
KINGS	authority, lawfulness, success. Kings are the leaders of the Minor Arcana.

As you color the court cards, meditate on what they mean to you. Do you recognize them in any specific people in your life? When reading the tarot, people often assign court cards to the people that surround them. This can be very helpful: when the court cards appear in a reading, you know a certain person is involved somehow — or the tarot could be urging you to go to that person for guidance or support.

And ask yourself: which court card do *you* identify with? Choosing a card to be your signifier can add a depth of meaning to your readings, helping you to understand where you are on your journey to achieving your goals. For example: are you a novice Page, or a Queen building her community? But choose carefully — it's not just about the rank of the court card, but the suit that makes them who they are…

Write down any thoughts you have about court cards, people in your life, and your signifier card here:

..

..

..

..

..

..

..

..

WANDS

Fire. Will. Creativity. The Wands represent our passions, what motivates us and what we most want to achieve. This suit is a dynamic journey, taking us through turning points and making sure we're always connected to that which drives us onwards.

REFLECTION

What are you most passionate about? Work out where you are on this journey, and brainstorm some tarot reading questions here:

..
..
..
..
..
..
..
..
..
..
..
..
..
..
..
..
..
..

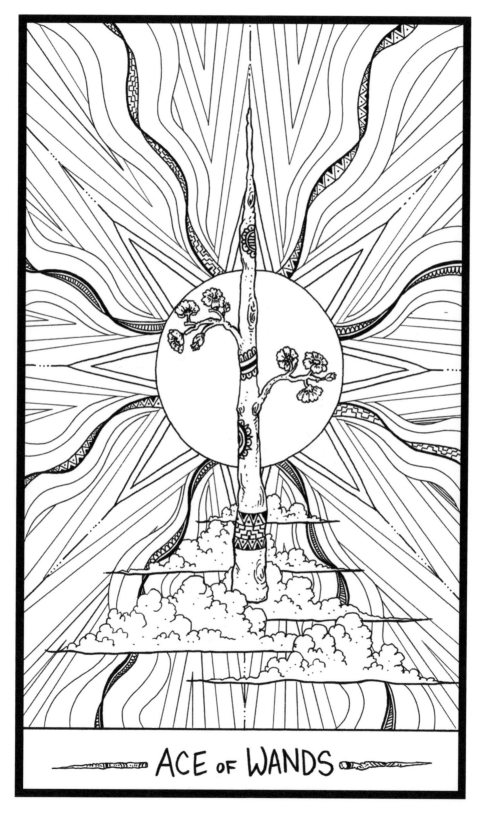

ACE of WANDS

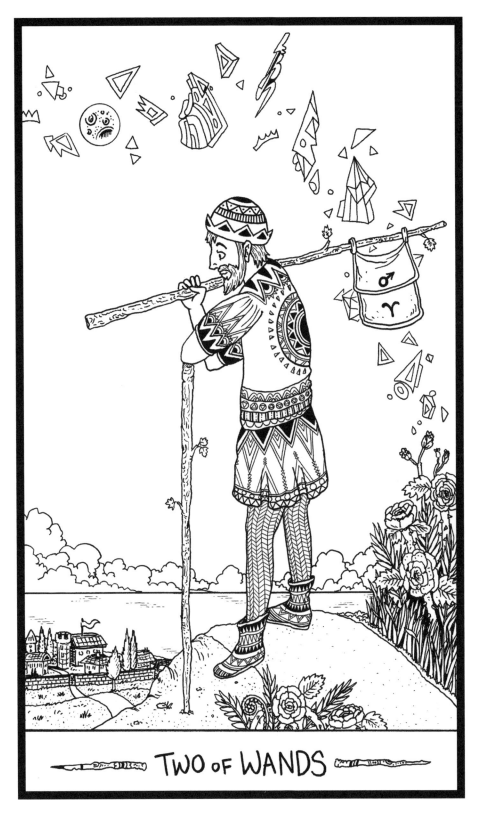

TWO of WANDS

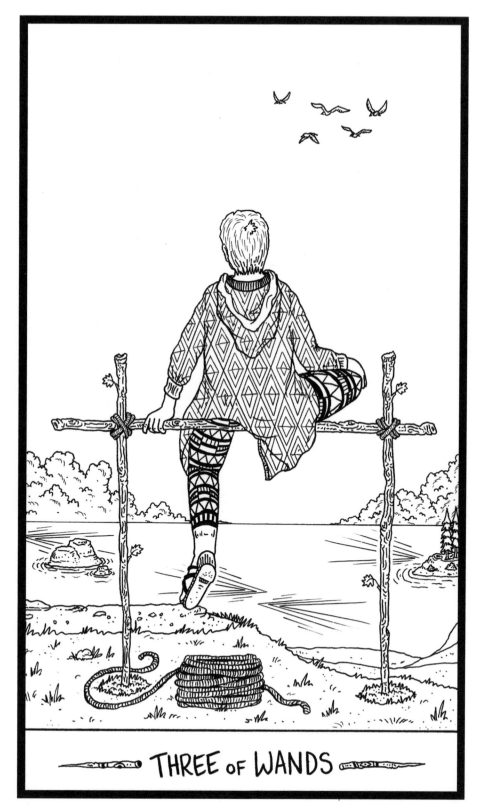

THREE of WANDS

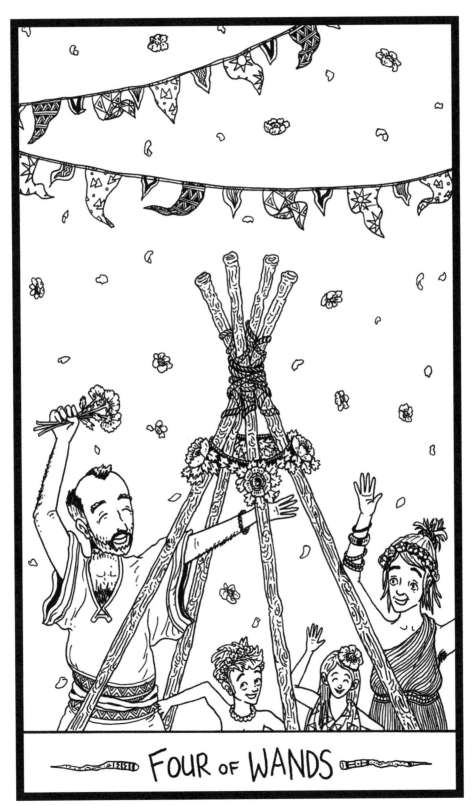

FOUR OF WANDS

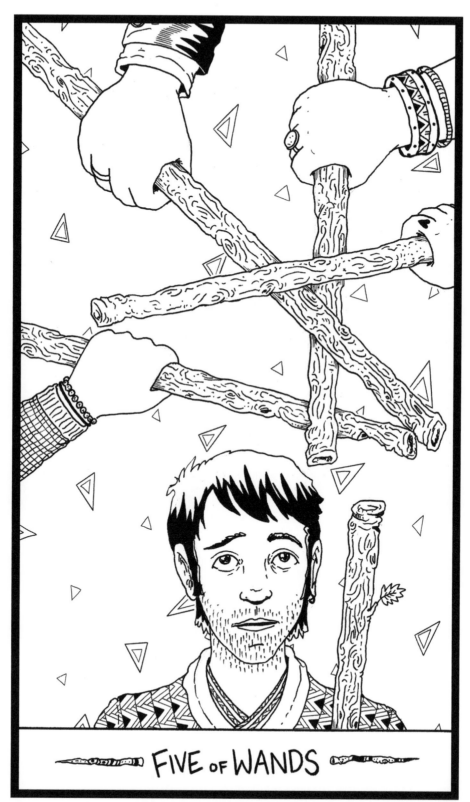

FIVE of WANDS

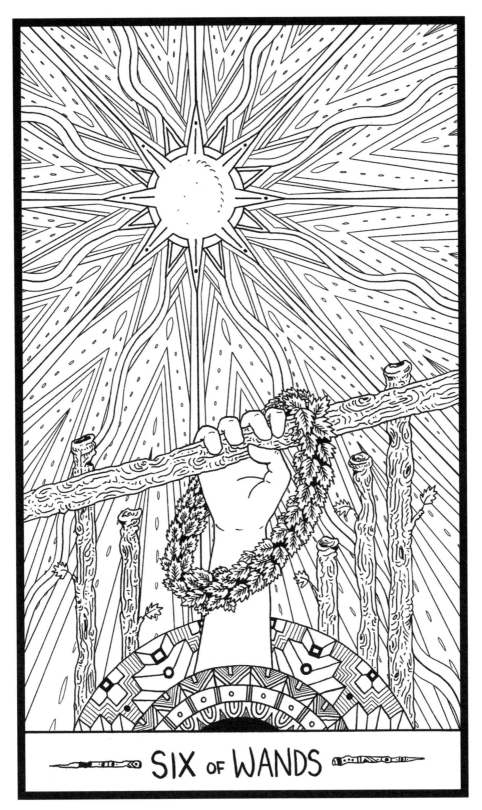

SIX of WANDS

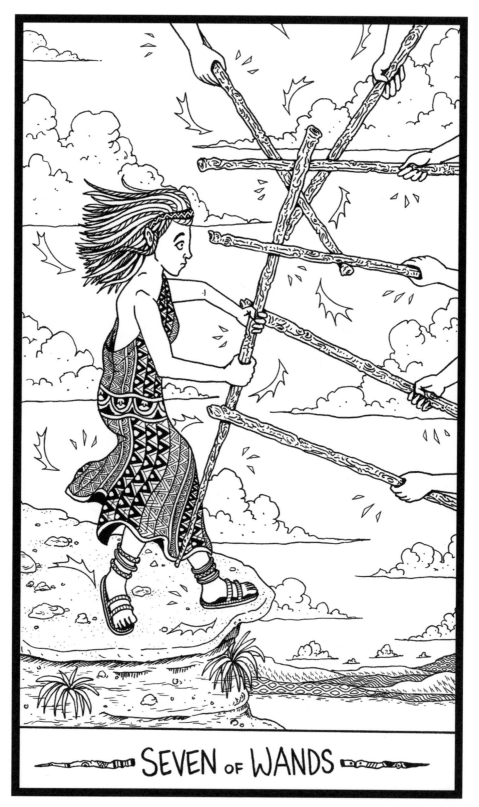

SEVEN of WANDS

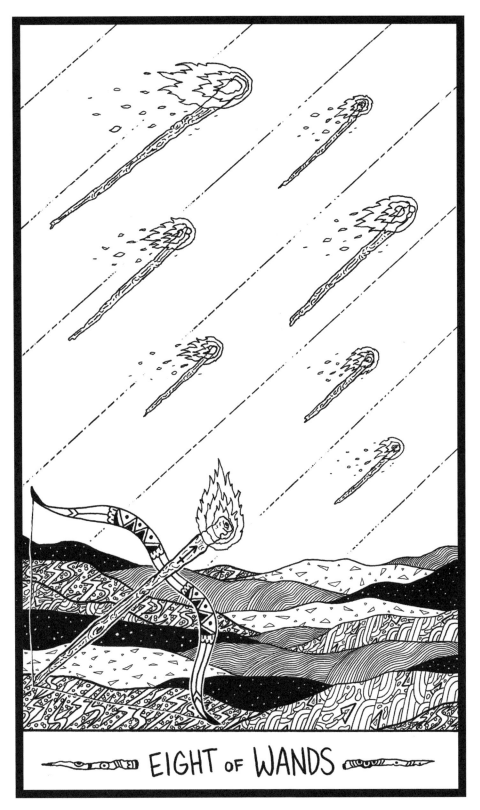

EIGHT OF WANDS

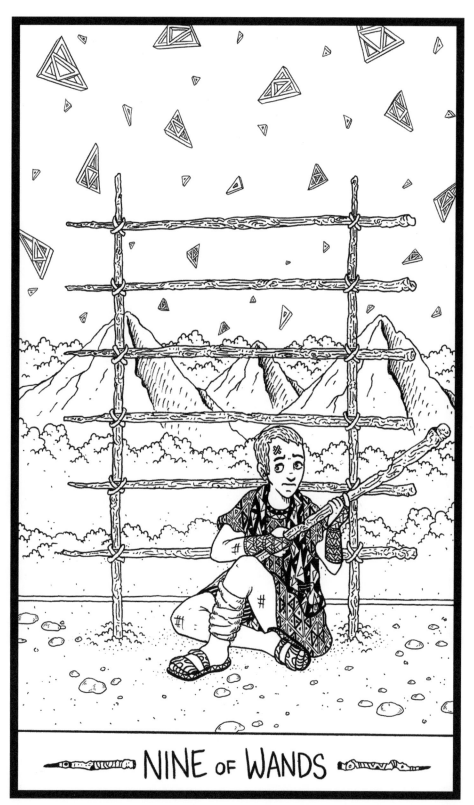

NINE of WANDS

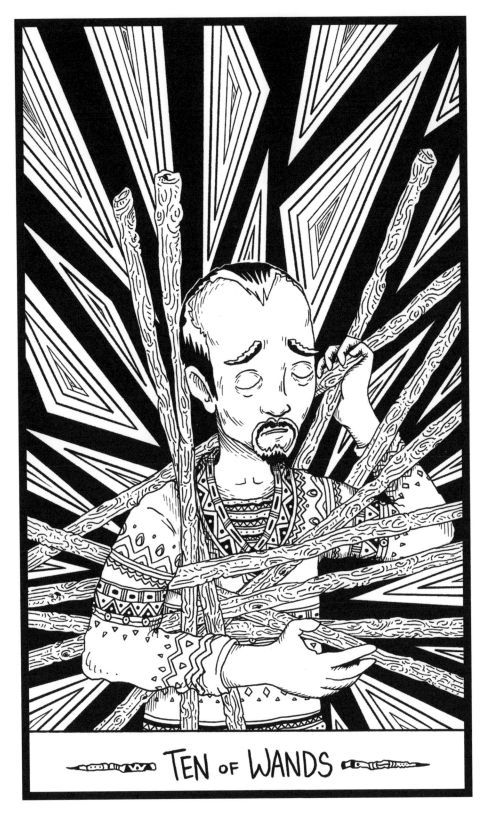

TEN of WANDS

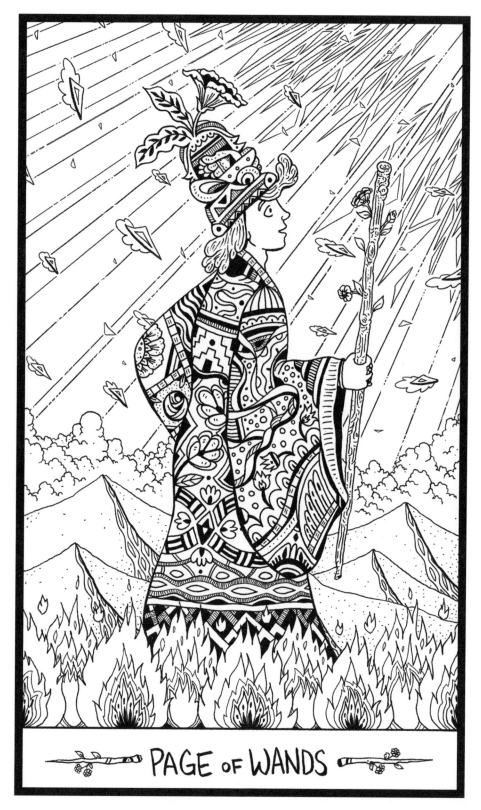

PAGE of WANDS

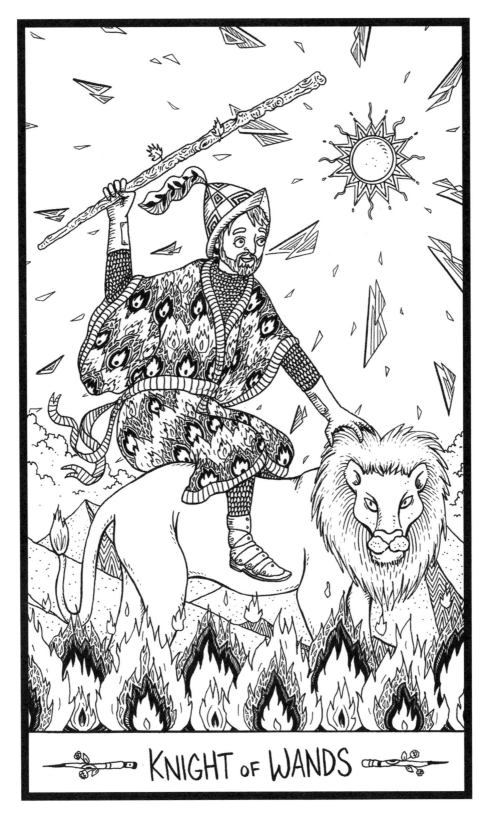

KNIGHT of WANDS

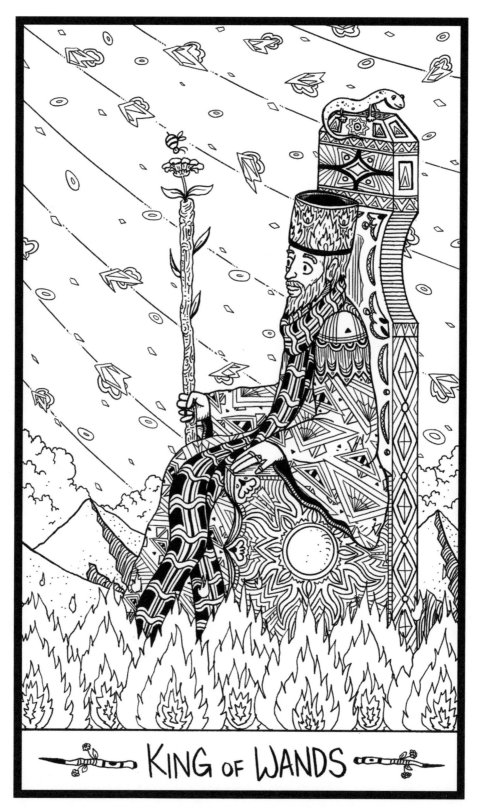

KING of WANDS

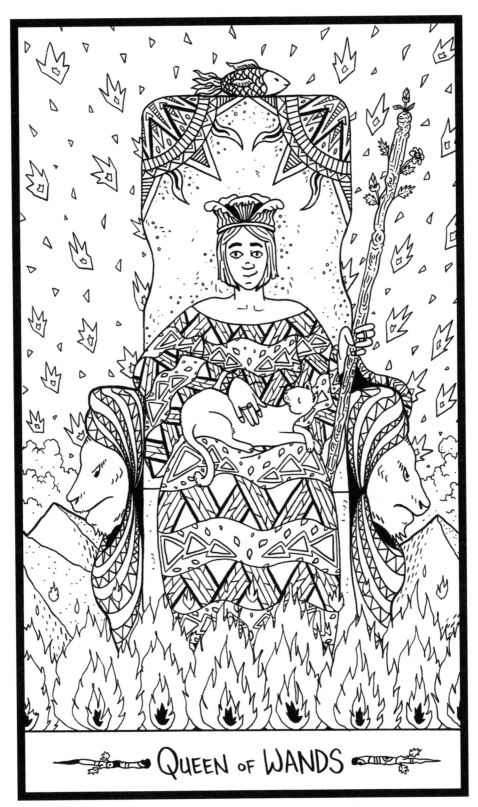

QUEEN of WANDS

CUPS

Water. Emotion. Connection. The Cups tell the tale of our inner lives, and how we relate to others. When this suit appears it's time to look both inward and outward to assess how we are balancing our inner lives with our external relationships.

REFLECTION

Do you feel like you connect well with others? How much of your inner self do you show in your relationships?

..
..
..
..
..
..
..
..
..
..
..
..
..
..
..
..
..
..
..
..

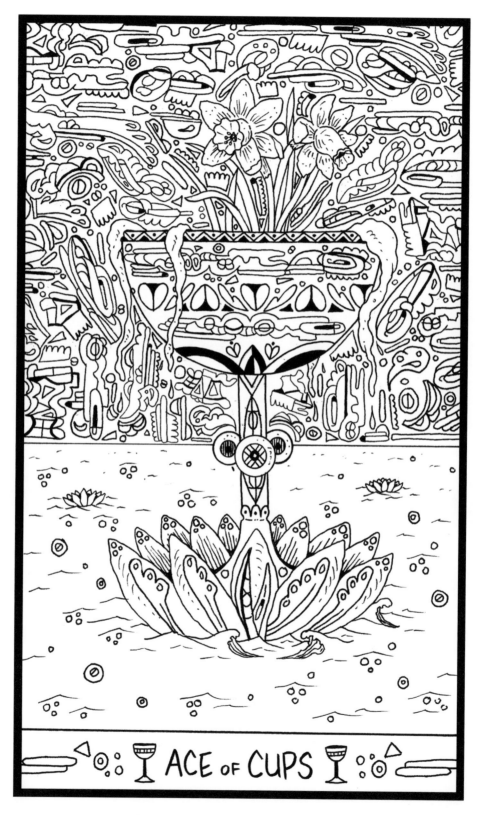

ACE of CUPS

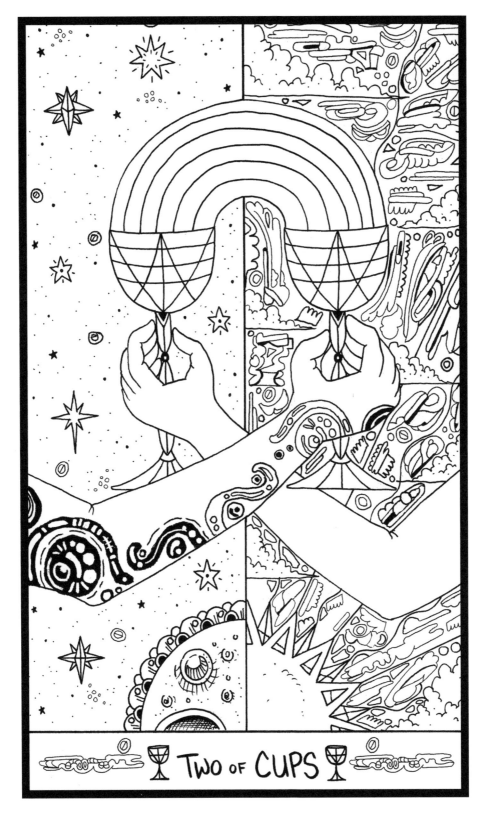

TWO of CUPS

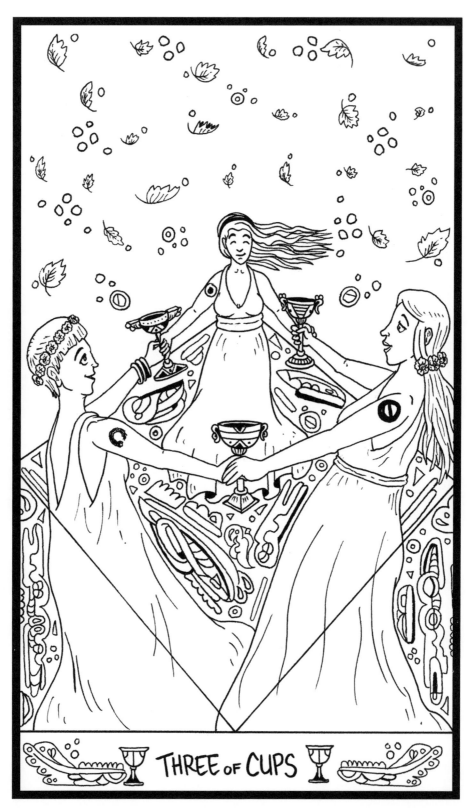

THREE of CUPS

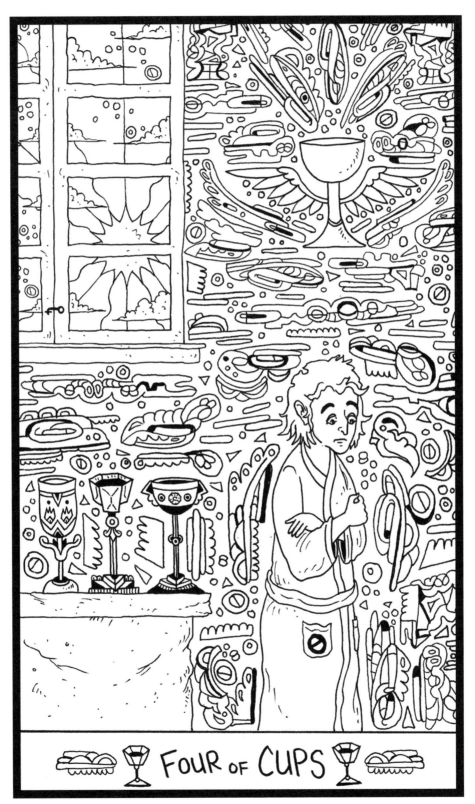

FOUR OF CUPS

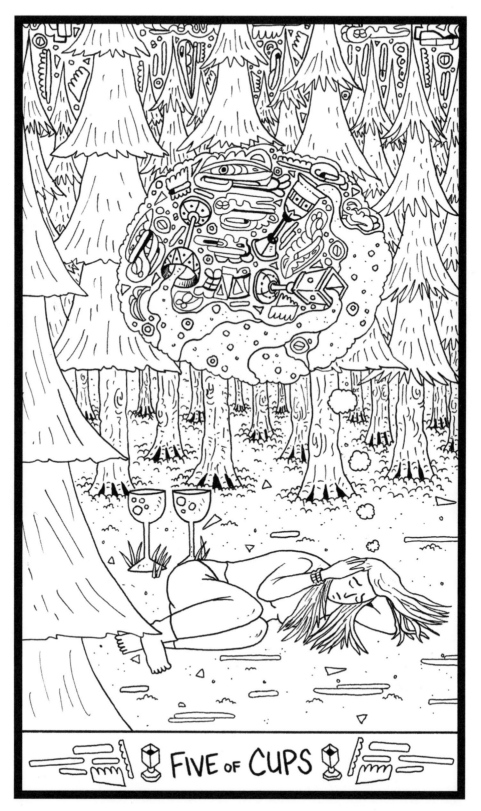

FIVE of CUPS

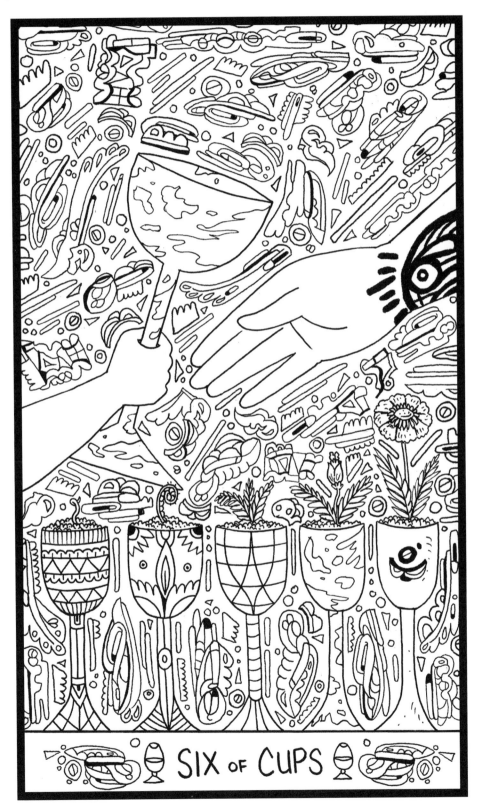

SIX OF CUPS

SEVEN of CUPS

EIGHT of CUPS

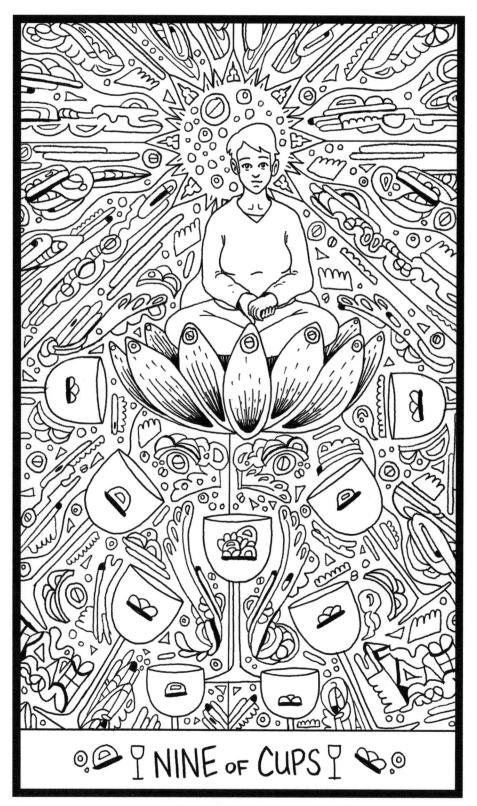

NINE OF CUPS

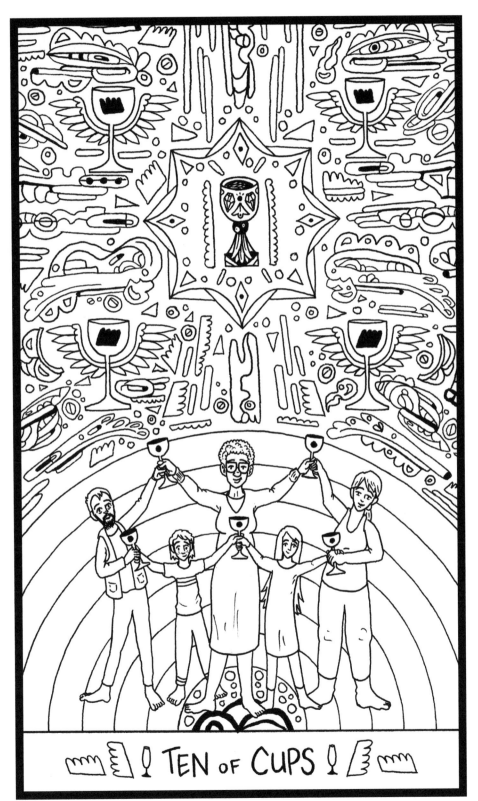

TEN OF CUPS

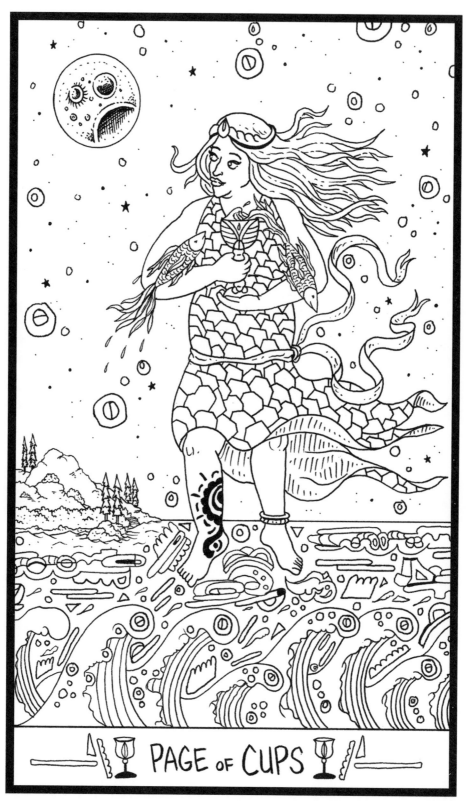

PAGE of CUPS

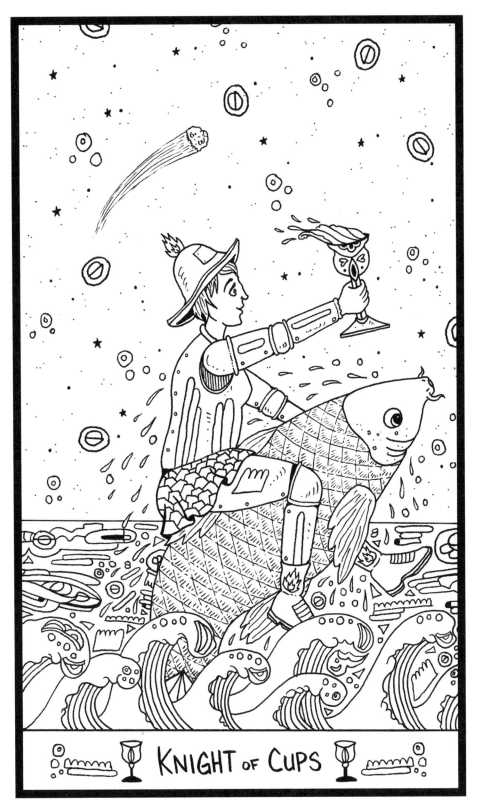

KNIGHT of CUPS

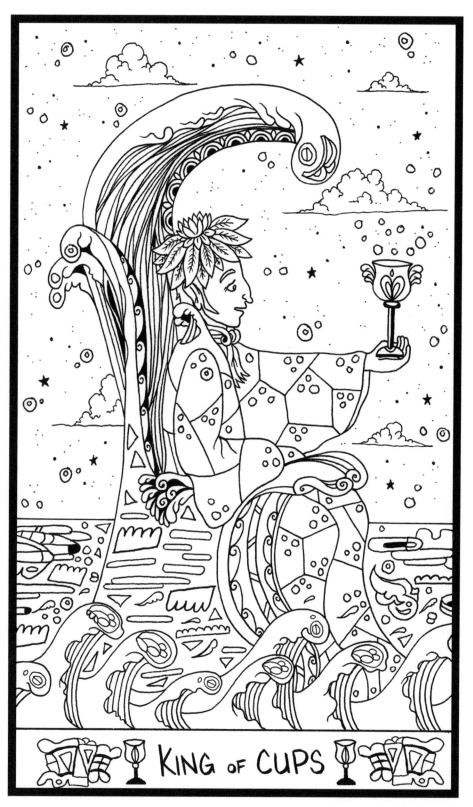

KING of CUPS

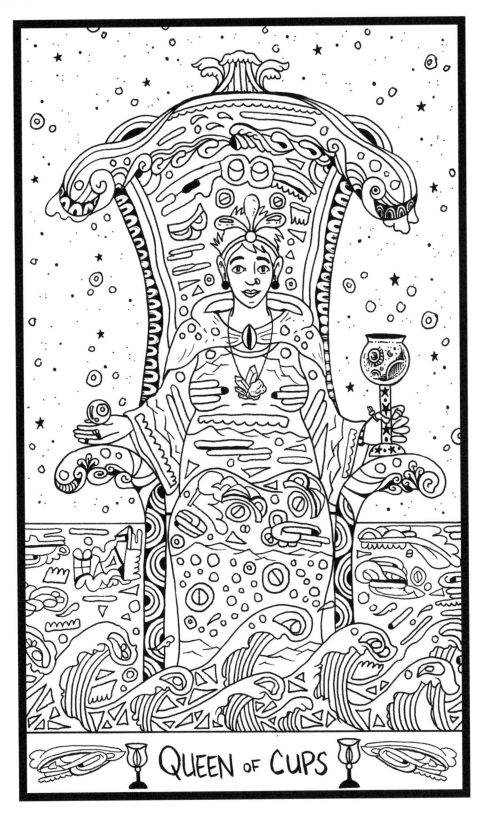

QUEEN of CUPS

SWORDS

Air. Thought. Hardship. The Swords represent logic, but the message woven through this suit is a difficult one: not everything in life is easy. Even so, the Swords assure us that we can rely on our minds to guide us through — because even when all seems dark, the solution is often right in front of us...

REFLECTION

What have you already learned from life's hardships? Every moment of turmoil is a moment of growth, after all... And you're already so much stronger than you think.

...
...
...
...
...
...
...
...
...
...
...
...
...
...
...
...
...
...

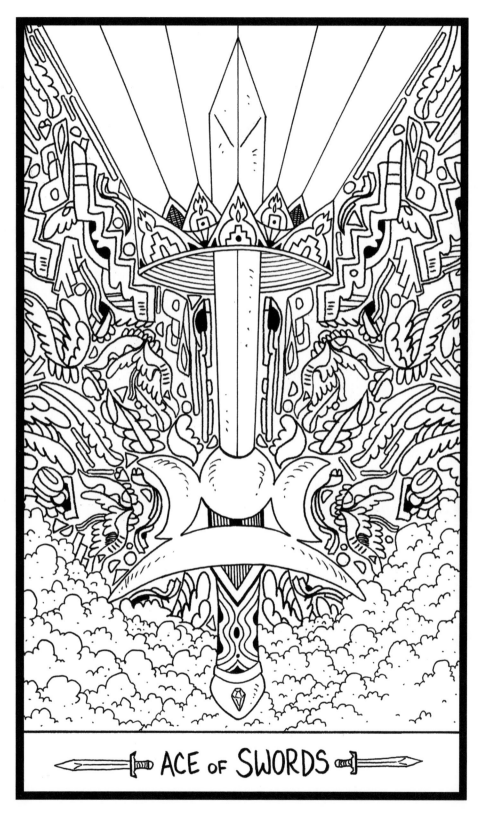

ACE of SWORDS

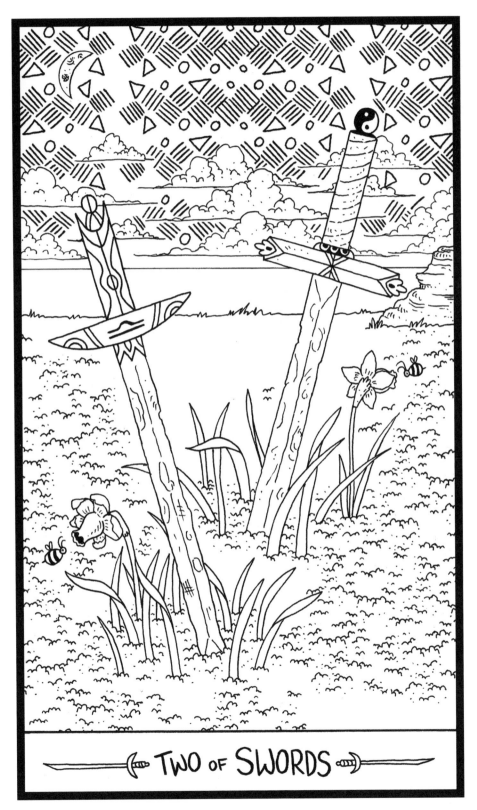

TWO of SWORDS

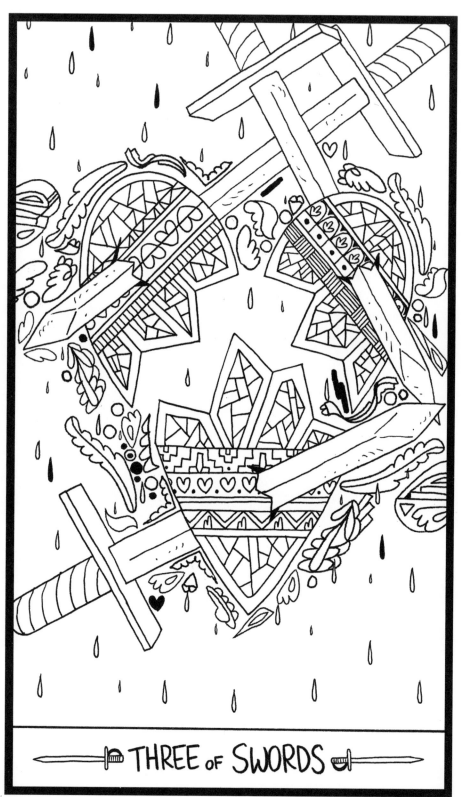

THREE of SWORDS

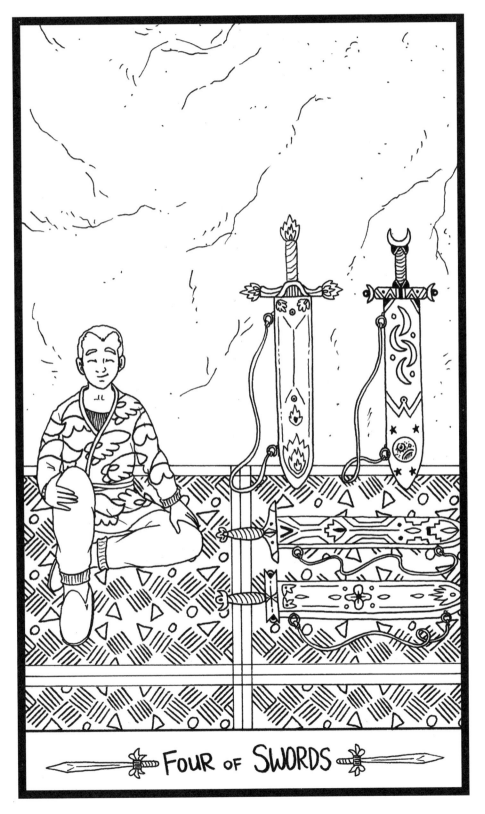

FOUR OF SWORDS

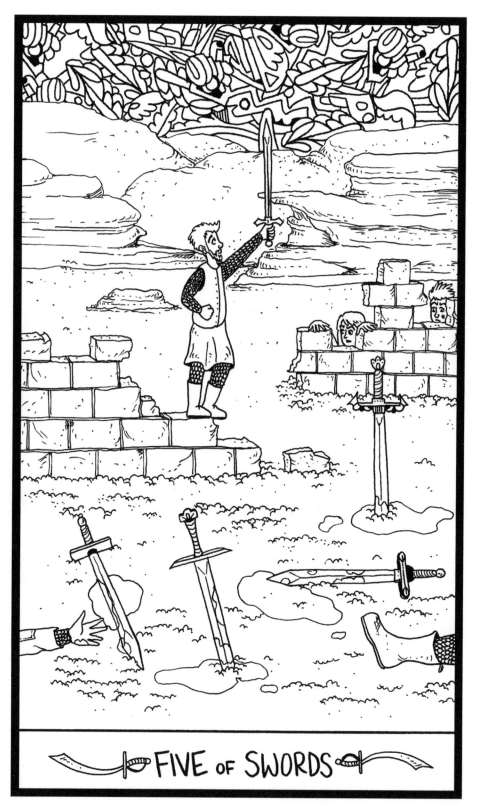

FIVE of SWORDS

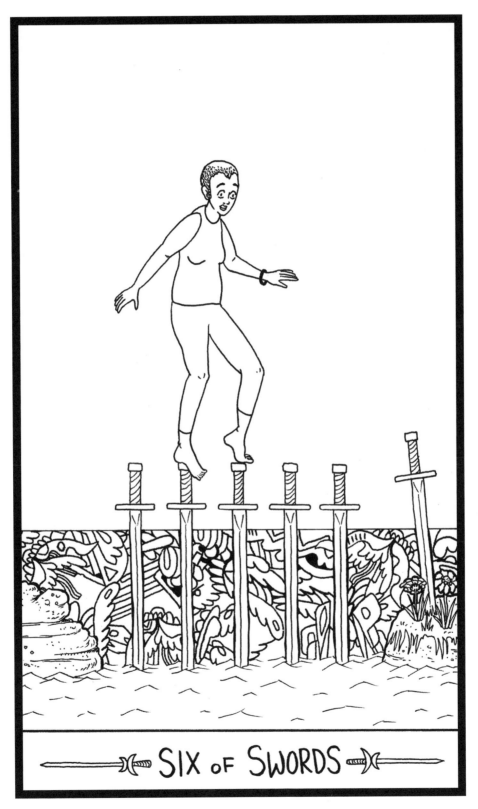

⋯⊰⊱⋯ SIX of SWORDS ⋯⊰⊱⋯

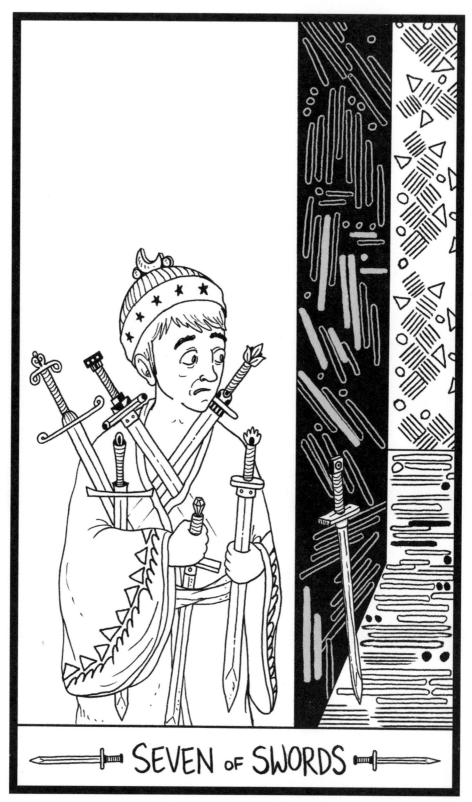

SEVEN of SWORDS

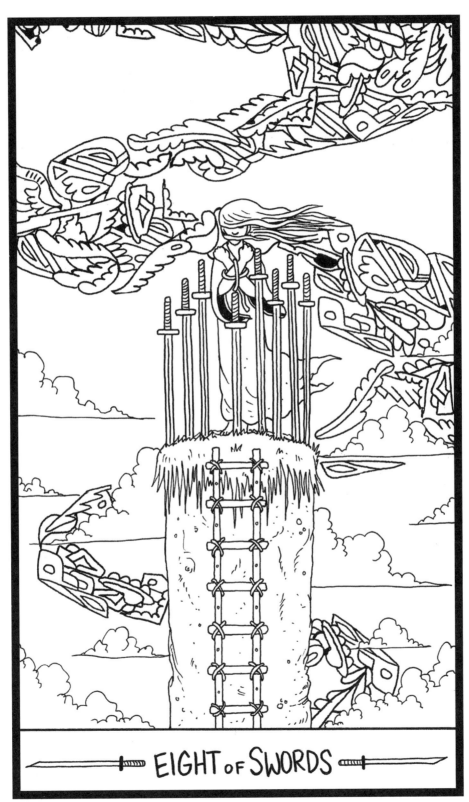

EIGHT of SWORDS

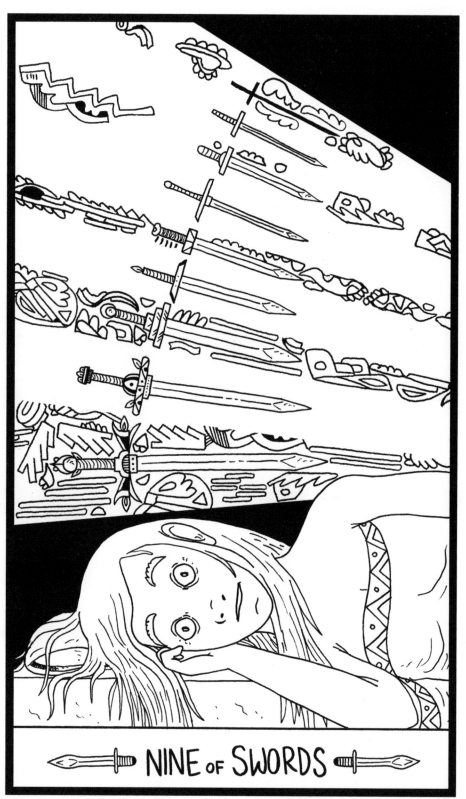

NINE of SWORDS

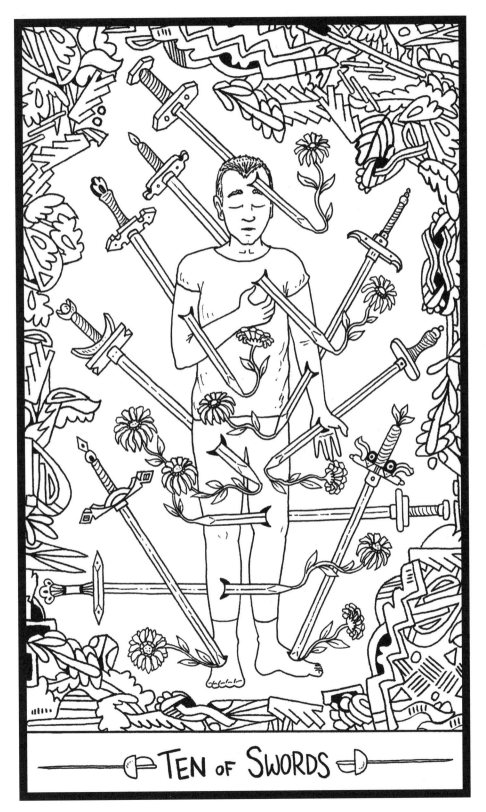

TEN OF SWORDS

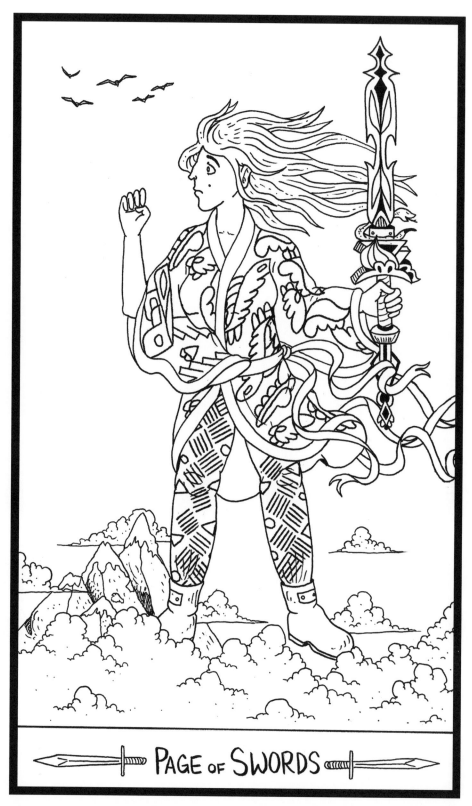

PAGE of SWORDS

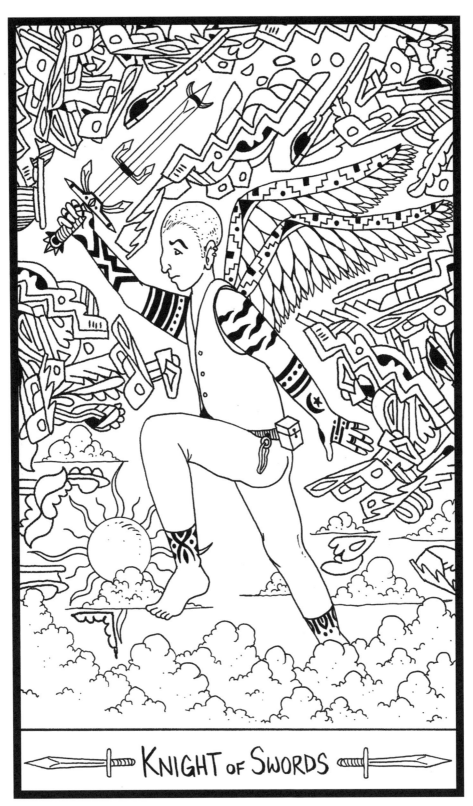

KNIGHT of SWORDS

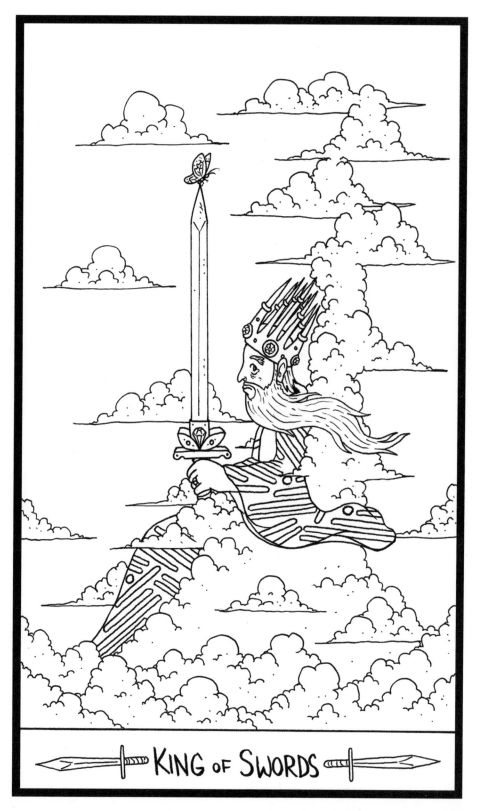

KING of SWORDS

QUEEN OF SWORDS

DISKS

Earth. Home. Finance. The Disks are concerned with life's most practical matters, from personal wealth to the homes we build — and the people we choose to share our lives with. If you need some solid, dependable advice, the Disks will be there for you.

REFLECTION

Do you think of yourself as being a practical person? How do you handle life's practicalities, and what do you struggle with?

..
..
..
..
..
..
..
..
..
..
..
..
..
..
..
..
..
..
..
..

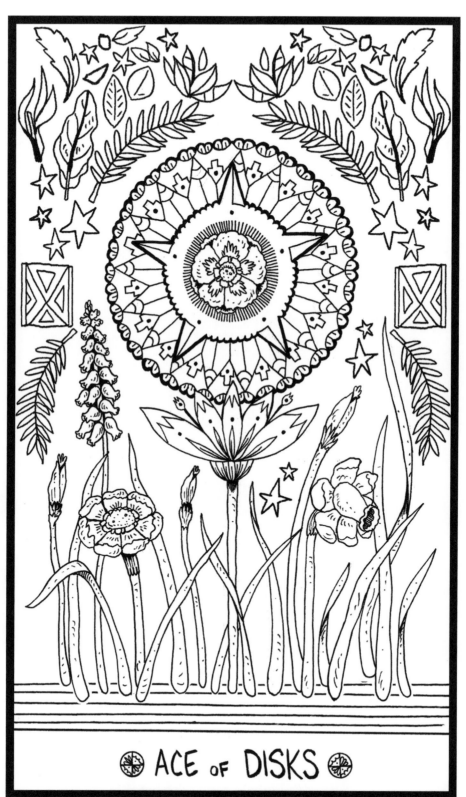

⊛ ACE of DISKS ⊛

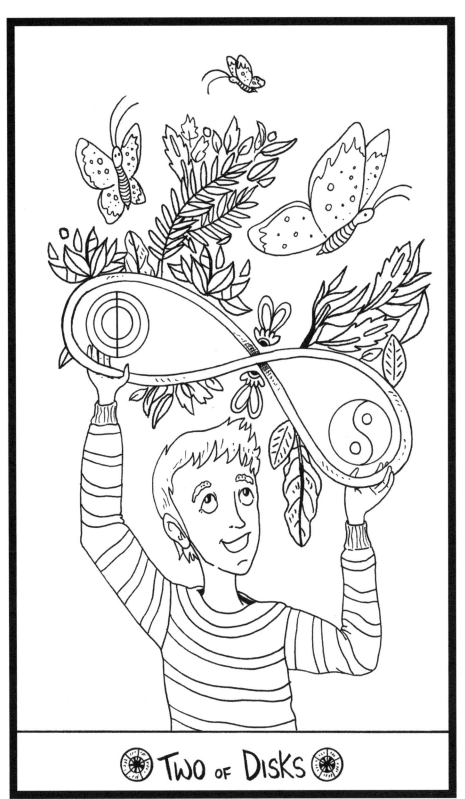

✺ Two of Disks ✺

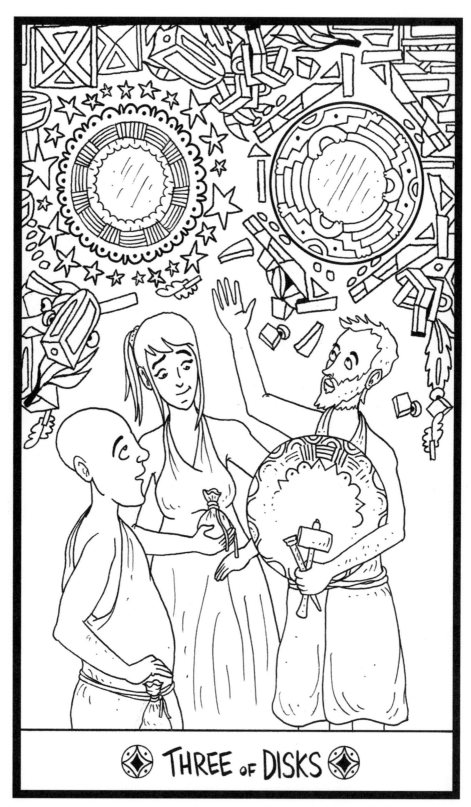

◈ THREE of DISKS ◈

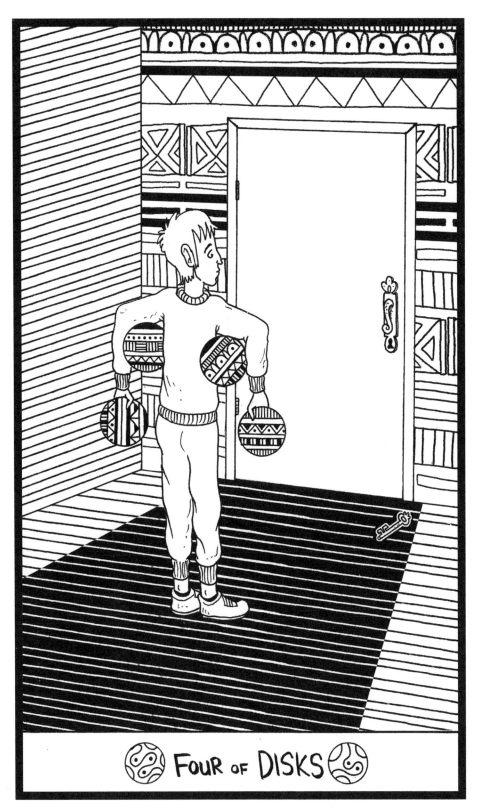

FOUR OF DISKS

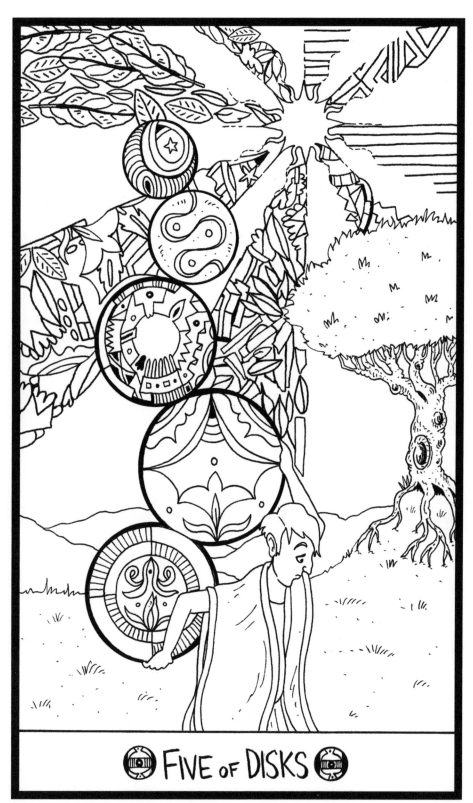

FIVE of DISKS

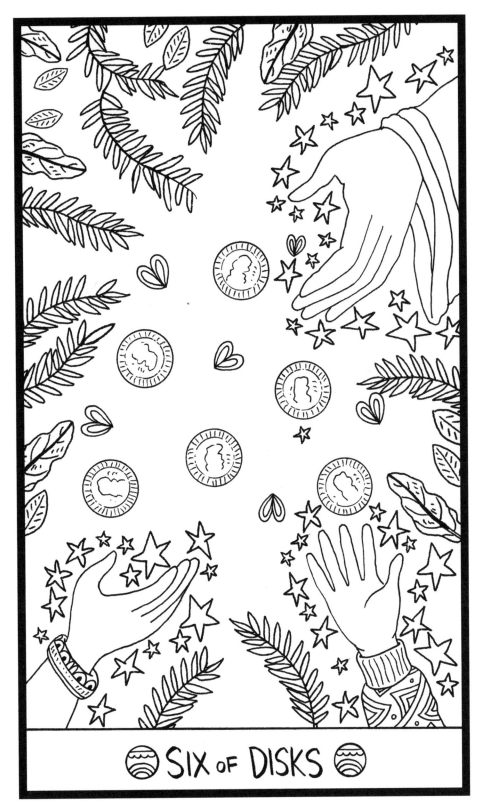

SIX of DISKS

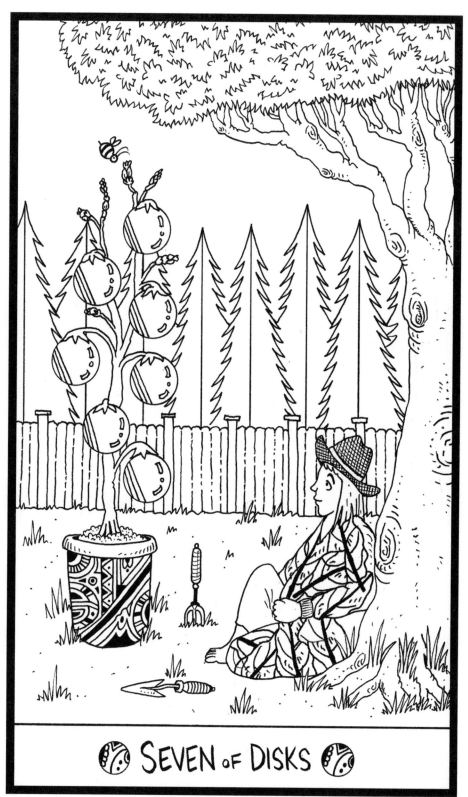

🜨 SEVEN of DISKS 🜨

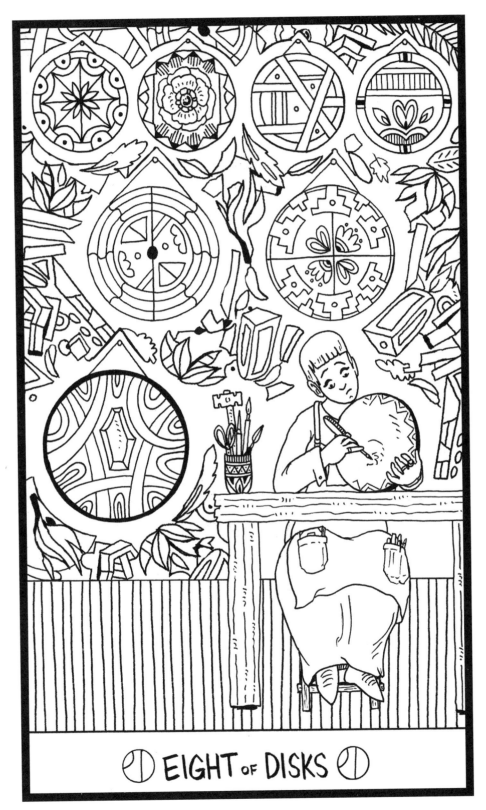

EIGHT OF DISKS

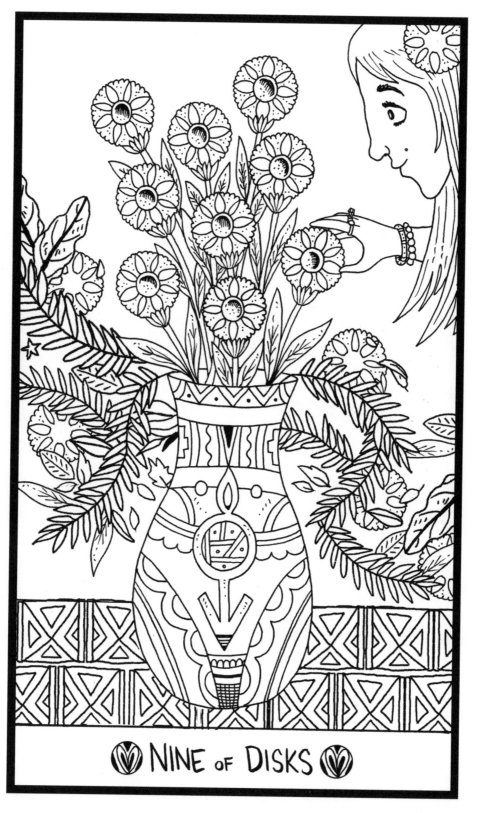

NINE of DISKS

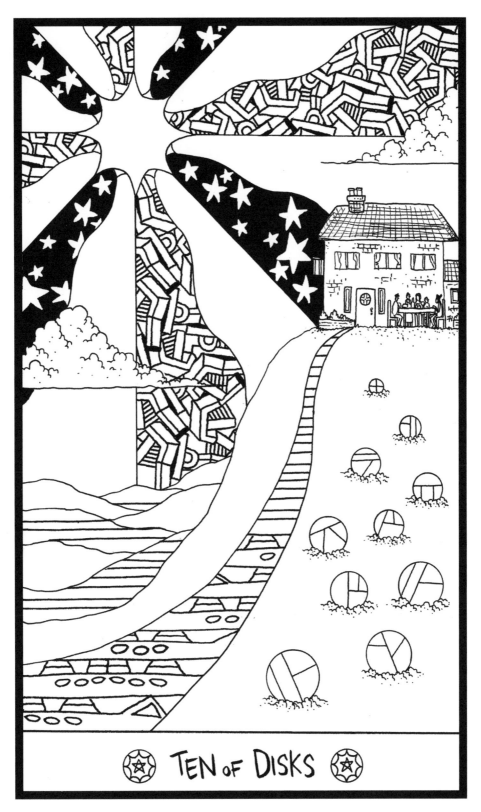

TEN of DISKS

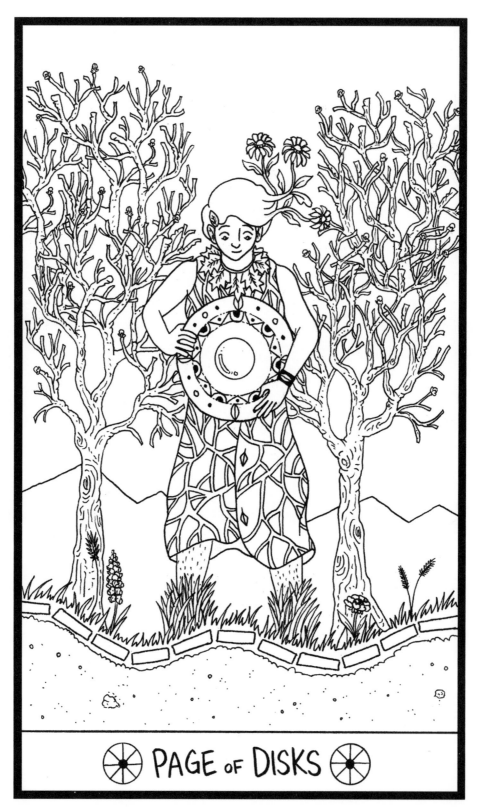

✷ PAGE of DISKS ✷

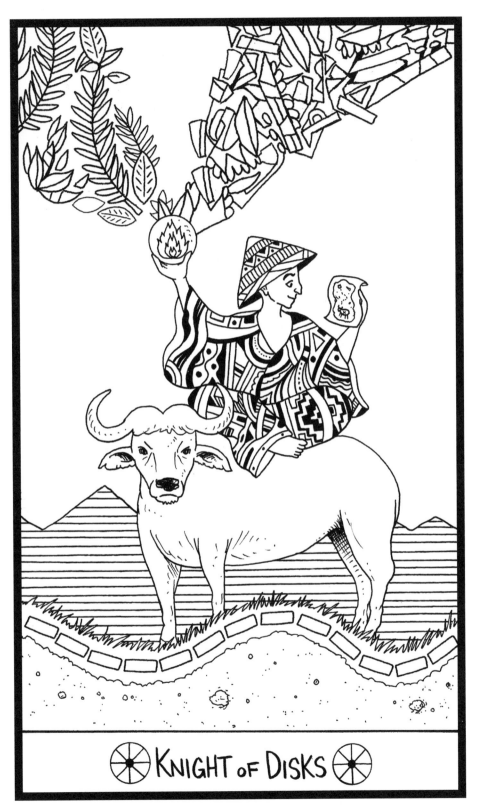

⊕ KNIGHT OF DISKS ⊕

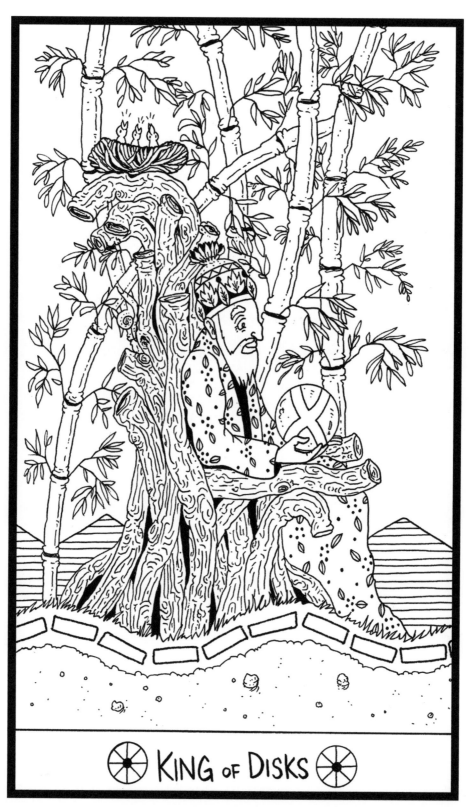

⊛ KING of DISKS ⊛

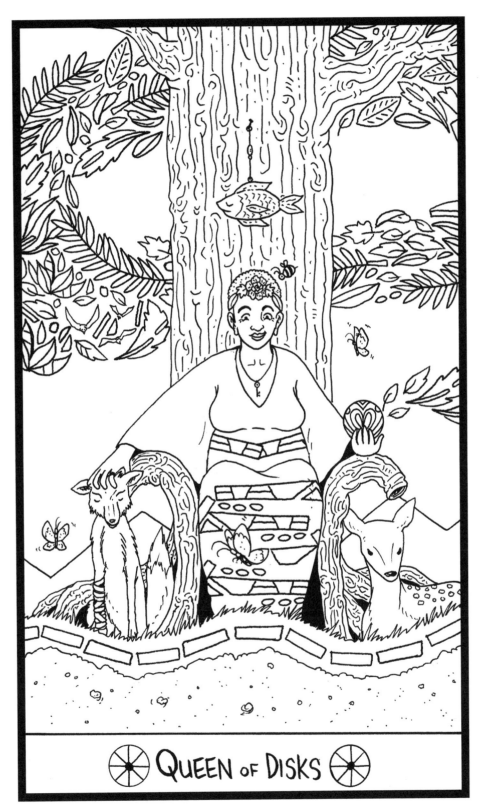

QUEEN of DISKS

FURTHER READING

If you're interested in reading more about tarot — or the esoteric and mythological elements that can be found within the *Luna Sol Tarot* — these books are a great place to start…

Seventy-Eight Degrees of Wisdom by Rachel Pollack

The Tarot: A Key to the Wisdom of the Ages by Paul Foster Case

Tarot and the Archetypal Journey by Sallie Nichols

The Crowley Tarot by Akron & Hajo Banzhaf

Practicing the Tao Te Ching by Solala Towler

Lao Tzu: Tao Te Ching (as translated) by Ursula K. Le Guin

Trickster Makes This World by Lewis Hyde

Parallel Myths by J.F. Bierlein

The Hero with a Thousand Faces by Joseph Campbell

Gender Trouble by Judith Butler

THE LUNA SOL TAROT

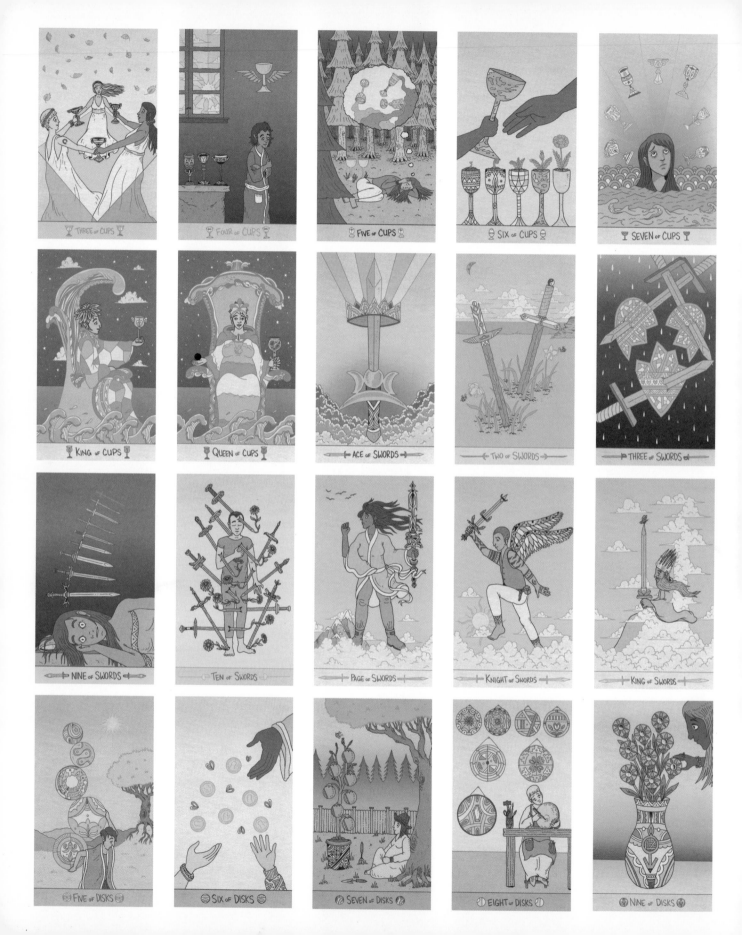